FF 55 MM

W9-BJD-872

P 39 80 A
 82 B

 82 A ?
52 m TIFFIN 812

 +4 DIOPTER
HAVE 1.4 81 B P 41
 2 FL-DAY FLUORESCENT
 LT/DAYLT FILM
 2.4 80 A P 35
 1 B (P 34)
 -
 3-4 POLARIZER

 ASA
 FILTER FACTOR (F₁ X F₂)

 EXPOSURE
 W/ FILTERS
 PP 26 - 27

Amphoto Guide to
Filters

Amphoto Guide to
Filters

Robb Smith

AMPHOTO
American Photographic Book Publishing Co., Inc.
Garden City, New York 11530

Note: In the appendix of this book, you will find a table converting U.S. Customary measurements to the metric system. You will also find a table for ASA and DIN equivalents.

All photographs were taken by the author unless otherwise noted.

Library of Congress Cataloging in Publication Data
Smith, Robb.
 Amphoto guide to filters.

 Includes index.
 1. Photography—Light filters. I. Title.
TR590.5.S56 771.3'56 78-21937

ISBN 0-8174-2132-7 (softbound)
ISBN 0-8174-2458-X (hardbound)

Manufactured in the United States of America

OTHER BOOKS IN THE AMPHOTO GUIDE SERIES

Available now

Amphoto Guide to Basic Photography
Amphoto Guide to Black-and-White Processing and Printing
Amphoto Guide to Cameras
Amphoto Guide to Lighting

To be published

Amphoto Guide to Available Light Photography
Amphoto Guide to Darkroom Special Effects
Amphoto Guide to Non-Silver Processes
Amphoto Guide to Photographing Models
Amphoto Guide to Selling Photographs
Amphoto Guide to Travel Photography

Contents

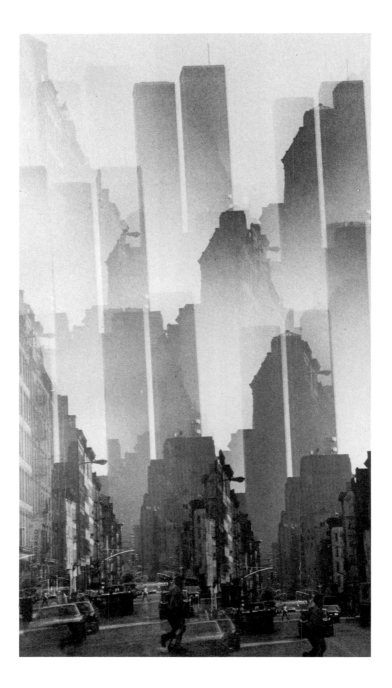

1

The Basics

This book is about filters and other attachments that you put in front of your lens to improve pictures or get special effects. Once you learn how to use them, picture-taking becomes more fun because you have more control. Endless variations in mood, interpretation, and emotional impact are possible using colored filters and special-effect attachments. You can get brilliant or subtle color, diffusion, star bursts, rainbows, multiple-image patterns, and an incredible number of combination effects, depending on what you use and how you use it.

The purpose of this guide book is to describe these devices and present straightforward, practical advice on how to make them work for you. Although some theory is included—the minimum necessary to make good exposures—the emphasis is on the pictures you get. Effectively using filters and special-effect attachments is primarily a matter of looking and doing, not thinking or memorizing some formula. The approach here is above all practical. You will see what filters and other attachments look like, how to attach them to your lens, how to figure your exposure, and how to get around any figuring at all. There are examples of typical effects that can be achieved with each filter and device covered. There are suggestions on how to use them in a straightforward manner and how to vary technique for

additional effects. In many cases, both manufactured items and similar make-it-yourself devices are described.

Most of the devices covered here are available either through your local photographic dealer or through mail-order ads in the major photo magazines. Also included are some ideas on how to make some of these attachments yourself. For example, while it is nice to have the control

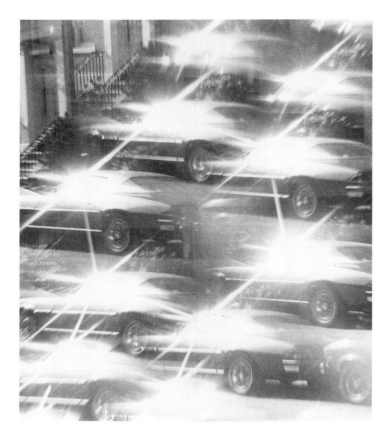

Filters used singly or in combination provide an endless variety of exciting effects. This photo was made using a multiple-image prism with five parallel facets in combination with a variable star filter.

provided by a numbered diffusion or fog filter, in a pinch you can get a similar misty effect simply by breathing on the lens and taking the shot before the moisture on the glass evaporates. The effect varies but is always interesting.

The *Amphoto Guide to Filters* provides a solid foundation of basic information about contemporary filters and special-effect attachments. It abounds with tips derived from the experiences acquired over the years by dozens of photographers. At times, the advice given differs from that provided in other photo manuals, the reason being that the information here comes from practice, not theory.

FILTER FACTS

A photographic filter is a piece of optical-quality glass, plastic, or gelatin that changes the character of the light used to make a picture. To get a general idea of what a filter will do, hold it up to your eye or put it over the lens of a single-lens reflex (SLR) camera and look through it. In the case of color photography, what you see will be close to what you

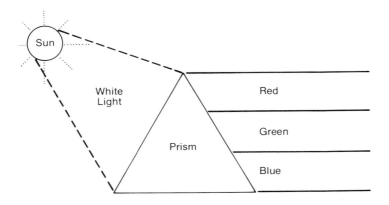

White light contains three major bands of color — blue, green, and red. These can be seen by passing white light through a prism.

11

get. If you are experienced in translating color into black-and-white, then you can also guesstimate effects for black-and-white work.

The various colored filters used in photography are designed to absorb selected portions of the spectrum that makes up white light. White light is actually made up of a rainbow of colors that go from the very short violet and blue wavelengths through green, yellow, orange, and red. When all colors are mixed, the result is "white light." When these colors are separated by selective absorption, colors result. For example, a yellow automobile reflects yellow light and absorbs blue. A yellow filter also absorbs blue light and passes yellow, which is actually made up of a combination of various proportions of red and green colors. By absorbing some colors and passing others, filters have a major effect on film, which is sensitive to visible light and often to invisible ultraviolet and infrared as well.

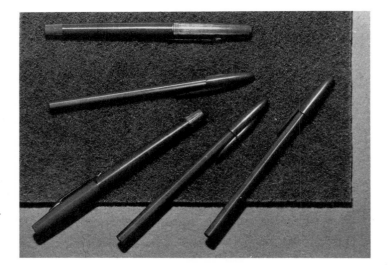

Colored filters absorb selected portions of the spectrum. This unfiltered black-and-white conversion shows bright red pens on a deep green pad. The gray border on left and bottom of the picture is a neutral gray card which reflects all colors and therefore is unaffected by the filters.

12

A No. 25A (Red 1) filter darkens the green pad and lightens the red pens.

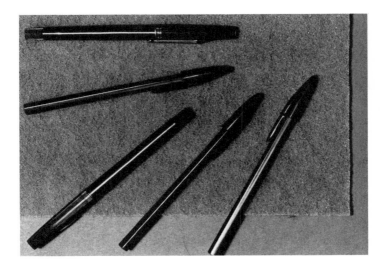

A No. 58 (Dark Green) filter lightens the green pad and darkens the red pens.

13

This explanation may sound complex, but in practice you can look at most filters and see what they do. Most books and magazine articles on filtration tend to run on at length about the physics involved in filtration. Yet it is almost impossible to think about the nature of light and its selective absorption while taking pictures. And why bother? The only way to learn to use filters effectively is to use them and take a good, long look at the results.

Sometimes the results are dramatic. Sometimes the effects are so subtle that they are lost entirely. Taking the time to carefully examine the pictures and illustrations throughout this book can give you a good idea about the major effect a filter will have, and from them you can develop some idea of the filters you might want to buy and those which do not interest you.

The best advice is that you learn what a filter does, and don't get overly involved with how it does it. If you want theoretical background, Chapter 7, "Advanced Filtration," gives detailed, technical discussions of color and light.

The colors each filter absorbs and those it passes are described in upcoming chapters. To get a general idea of what a filter does and how it is used, let's look at the case of a Medium Red (No. 25) filter used with a typical black-and-white film, such as Kodak Tri-X Pan. Think of light as being composed of three basic bands of color: blue, green, and red. A Medium Red filter passes only red light. It absorbs blue and green wavelengths. When you put one of these filters on a lens, the photo is made using only the red light available in the scene. For example, most of the light from a blue sky will be absorbed by the filter and radiated away as heat. The result is that the blue sky will hardly register on the film at all. The print from the resulting negative will show a dark sky, like a deep shadow, when compared with red or yellow objects in the scene. A red brick building will appear very light, almost white if the exposure was correct.

A Medium Red filter will absorb more than 80 percent of the light that would normally be available to make the exposure. If you have a camera with through-the-lens metering, you can use the meter to determine exposure through the filter. (For a Medium Red filter, this will probably result in slight underexposure, since most CdS and

14

Blue Silicone meters are more sensitive to red than the film is, but the results will usually be acceptable.) For precision, you could meter the scene using your regular light meter and then open up the lens an extra 2½ to 3 f-stops from the meter indication to compensate for the light absorbed by the filter. Or you could use ⅛ the shutter speed indicated on the meter. In a correctly exposed shot, neutral gray subjects, such as cement and clouds, are reproduced normally; blues and greens darker than normal; and reds lighter. The effect can be dramatic, particularly in landscape photos.

FILTER TYPES

Filters fall into several general categories, each of which is dealt with separately here.

In black-and-white photography, there are two types: *correction filters*, which are used less often today than they should be; and *contrast filters*, such as the Medium Red filter just described, which lighten or darken specific colors. The filters used in black-and-white work can also be used for special effects with color film.

In color photography, *light-balancing filters* make minor changes in color quality; *conversion filters* make big changes, such as eliminating the reddish cast from photos taken on daylight-type slide film with photoflood light. *Color-Compensating filters*, available in a rainbow of colors, allow the photographer to make very precise changes in the nature of the light that strikes the film; however, because of the difficulty in finding just the right combination required for a particular shot, they are seldom used by amateurs.

Under the category of *special-purpose filters* are: *polarizers*, which eliminate reflections from glass and water and darken blue skies; *graduated filters*, which change the contrast or color of part of a scene; *circular color filters*, which have a clear central spot surrounded by color; and *neutral density filters*, for exposure control.

Then there are a large variety of special-effect filters and attachments. This group includes diffusers, fog filters, multiple-image prisms, star-effect filters, and masks. Filters from other categories can also be used for special effects.

15

Blue skies come out unnaturally light in unfiltered black-and-white photos, causing puffs of clouds to be lost entirely. Without a filter, this photo seems to have no subject at all.

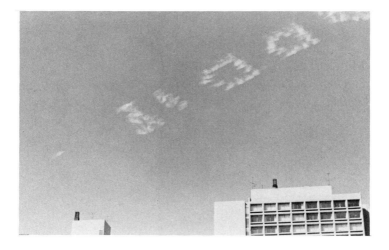

A Medium Red (No. 25) filter darkens the sky and brings out the skywriting, which is the real subject of this photo. An orange filter could also have been used; however, the sky darkening would not have been as strong. The filter darkened only the blue sky; the buildings, which were a neutral color, were unaffected.

16

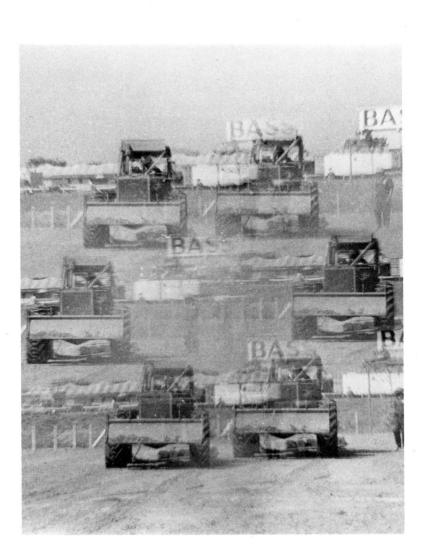

An ordinary bulldozer moving down a field becomes a dramatic event when photographed through a combination of Orange (No. 15) contrast filter, which darkens the sky, and a six-facet multiple-image prism.

NOMENCLATURE

Unfortunately, there is no worldwide standard for describing filters. In this text you will find general descriptive terms, such as Dark Red, Light Yellow, Conversion, and so on, along with the filter's Wratten number, which is the system most widely used in the United States.

The slight differences that exist between similar filters made by different manufacturers have little practical effect so far as the resulting pictures are concerned. Besides, everyday filter usage isn't very exact anyway, so there is no need to worry about minor differences. An orange or deep-yellow filter will do pretty much the same thing for you, regardless of who manufactures it or what it is called.

Designers of precision optical equipment that incorporate filters don't worry much about names either. They look at spectral transmission graphs that show exactly how much of each wavelength the filter actually absorbs and how much it passes. These graphs, or *filter curves*, are available from manufacturers, and you may find them interesting if you have a technical turn of mind. They have no use in general photography.

Quality does vary from one brand to another and, as with lenses, you generally get what you pay for. For example, a poor-quality filter will introduce slight aberrations into the picture, usually a slight reduction in apparent sharpness. On the other hand, some filters with excellent optical characteristics are easily damaged.

You should purchase glass filters of optical quality for your serious work. These may be solid colored glass, called dyed-in-the mass glass, or a sandwich of two pieces of optically flat glass bonded together permanently with a colored resin-bonding agent. Both types are durable and can ordinarily be used in water or low-pressure environments without problem.

Filters that consist of a piece of colored gelatin sandwiched between two pieces of glass are less durable because liquids can get to the gelatin and cause it to discolor.

Some plastic filters provide adequate quality.

Pure gelatin filters come in squares, are relatively inexpensive, and are very fragile; a single drop of water or a

18

fingerprint can ruin one. They are generally used with a compendium-type lens hood or professional filter holder and are found mostly in commercial photo and motion-picture studios. Gelatin filters are a poor choice for use outdoors. On the plus side, they provide superior optical quality. Unless you are a working professional who can charge the cost to an assignment budget, stay away from gelatin filters.

Most camera lenses have a threaded front for screwing on filters, lens hoods, and other attachments. Some

Direct screw-in or bayonet-mount filters are the most convenient types to use. Glass and plastic filters mounted in plastic rings are easiest of all to handle because the plastic will not bind or freeze up if you happen to thread it incorrectly. If you accidentally cross-thread a metal filter ring, it can be very difficult to remove.

19

have a bayonet-type attachment system. Others make no provision for mounting filters but will usually accept a slip-on type mount that slips over the outside of the lens and may be held in place by a set screw. The accompanying illustrations show the various types.

Unlike lenses, which must be mounted perfectly, filters may be mounted casually or not at all. In a pinch, some photographers will use masking tape to hold in place filters that are too small or too large for the lens. This system works, but don't leave the tape on any longer than necessary; the gum on the tape can gunk up your lens. When you make a couple of filtered shots during a series of unfiltered shots, you may be able to hold the filter up in front of the lens with one hand and operate the camera with the other. When the camera is mounted on a tripod and you are experimenting with a variety of combinations, handholding may be the best solution. Mounting the filter, however, gives you mobility and ease of handling.

When purchasing a filter, you need to know the type of filter your lens accepts—direct screw-in, bayonet, or slip-on—and the diameter of the lens-attachment mount. This information is usually given in the camera manual or the literature that comes with the lens. It is not printed on the

Series size filters are available in various diameters. Series 5 (2.97 cm or 1 3⁄16″), 6 (4.06 cm or 1 5⁄8″), 7 (5.1 cm or 2″), and 8 (6.35 cm or 2½″) are the most common. The series filter is simply a glass disc seated in a metal or plastic ring for protection. It must be used with an adapter ring and retaining ring.

Series adapters permit the same series-size filter to be used with lenses of different filter-mount diameters. Shown here are series 8 adapters for 49 mm, 55 mm and 62 mm mounts.

lens itself, so if you are unsure, bring the lens with you and try the filter on in the store before you purchase it.

Filter mount size may be a consideration when purchasing a lens. For example, many Pentax wide-angle, normal, and moderate telephoto lenses have 49 mm filter mounts; Nikon has standardized on 52 mm where possible; other manufacturers have other standard sizes, with 55 mm and 58 mm particularly popular. If your most frequently used lenses have the same filter mount size, you are ahead of the game and may choose one lens over another of similar quality simply because one has a filter mount that is the same as other lenses in your system. This is also an argument for getting a zoom lens rather than several single-focal-length lenses.

Adapters allow you to use one filter with a variety of different filter mount sizes. In fact, in the series size filter system, the filter is designed specifically to be used with an adapter. In this system, the filter is mounted in a metal ring that usually has the size and color engraved on it for easy identification. The filter is placed in a retaining ring that

21

screws into an adapter ring mounted on the lens. For 35 mm SLRs, series 7 (5.1 cm or 2″) or 8 (6.35 cm or 2½″) is usually selected. Series 8 can also be used with most medium-format SLR cameras and many zoom lenses, but its large size makes it more expensive than series 7.

The series size concept is basically sound, but the disadvantage is that you have to handle three items each time you change a filter—adapter ring, filter, and retaining ring. It can turn into a juggling act and probably explains why most photographers today prefer direct fitting-type filters, such as the screw-in.

If you use filters regularly, it is probably a good idea to have direct fitting types for each of your most frequently

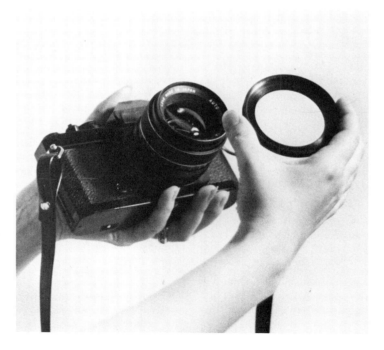

To use a series-size filter, first attach the adapter to the lens.

*Next put the series filter
into a retaining ring.*

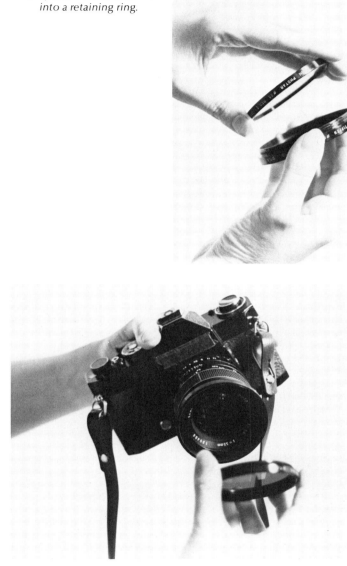

Finally screw the retaining ring/filter sandwich into the adapter on the
lens.

used lenses. If you feel you must choose between one size and another, choose the larger; you can then get an inexpensive step-up adapter ring that will allow you to use the filter on the smaller filter mount.

Step-up rings have external threads of one size and internal threads of the next larger size and are quite useful. For example, a selection of inexpensive step-up rings for a 49 mm screw-in filter mount will allow you to use 52 mm, 55 mm, 58 mm and 62 mm screw-in filters, depending on the ring selected.

Step-down rings allow you to use a smaller filter on a slightly larger filter mount. These are sometimes practical for use with normal and telephoto lenses. Use with wide-angle lenses generally results in vignetting because the angle of view of the lens will include part of the filter mount. As a rule of thumb, stepping-down is practical only if the difference in size is a matter of three millimetres or less.

Step-up and step-down rings may also be used when you want to combine filters or other attachments of different mount size. If you do combine different size filters, try to use the smaller diameter one closest to the lens. If the use of step-up and step-down adapters seems seductive, remember that it can be a real nuisance to sort through a jumble of adapter rings in a gadget bag. Taking adapters on and off the lens adds to the confusion, particularly in cold weather when your fingers are stiff.

Square gelatin or glass filters measuring 7.6 × 7.6 cm (3″ × 3″) or 10.2 × 10.2 cm (4″ × 4″) are held in place with a compendium lens hood or professional filter holder, which may also accept round series 8 or series 9 filters, depending on the size holder. Square filters are most frequently used by professional cinematographers, although they may also be found in some commercial photo studios.

HANDLING AND CLEANING

Treat a filter with the same respect that you give a good lens. Dirt and fingerprints on a filter or special-effect attachment produce diffused images of inferior quality. Keep your filters

clean, try not to scratch them, and they will give you years of service.

The quickest way to clean a filter is to blow on it to remove loose dust. Gently brushing with a soft, clean brush removes particles. You can make a substitute brush by bunching a piece of soft, clean, lint-free cloth and using it very gently, as though it were a brush. Breathing on the filter and then brushing sometimes adds enough moisture to loosen remaining grime. A brush or wadded cloth or photographic lens tissue will remove all but the most stubborn particles. Use lens cleaning fluid only as a last resort and only with glass filters. Those with gelatin in them can be damaged by the fluid.

Do not use eyeglass tissue. Lens tissue specifically formulated for cleaning lenses and filters is available in any photo store. To use this tissue, wad it and use it to brush the filter. Brush—don't scrub! And never use an abrasive on delicate optical-quality surfaces.

Handle filters and other optical attachments by the edges only. Fingerprints contain acid that can damage the surface of the glass if not removed immediately.

If you touch a gelatin surface with your fingers, you ruin it. Handle these fragile sheets of filter material by the edges only. Or use the tissue in which they are wrapped. If you need to cut a gelatin filter to size, as you might if you were to bind one together with a slide for some special effect or color correction, keep the filter in its tissue and cut through both the tissue and filter together.

EXPOSURE WITH FILTERS

Because filters absorb light, additional exposure is needed to compensate for the light loss. The amount of additional exposure needed varies, depending on the filter color and density. If you use a through-the-lens metering camera, just meter through the filter and let the camera do the figuring for you. It will automatically compensate. With deep-yellow, red, and amber-colored filters, you may need slightly more exposure than the metering system indicates, because CdS

and Blue Silicone systems are more sensitive to red than film is. If you need more exposure, use a slightly lower ASA setting on the camera. For example, with ASA 400 (DIN 27) black-and-white film and a Dark Red filter, you might set the camera for ASA 300 (DIN 26). With ASA 160 (DIN 23) tungsten-type (indoor) color slide film and a conversion filter for outdoor use, you could use a setting of about ASA 125 (DIN 22) as a starting point to find the exposure that seems best for your metering system. But don't worry about it. Most of your through-the-filter metered exposures will be adequate without any adjustment. In fact, with black-and-white film, slight underexposure increases the effect of the filter.

In situations where good exposure really counts, meter the scene without the filter, then adjust the exposure by using a filter factor, which tells you how much to increase the metered exposure for each filter.

The most frequently recommended method of using filter factors is to divide the ASA film speed by the filter factor and set that number on your meter. For example, if you are using a Medium Red (No. 25) filter (factor: 8×) with ASA 400 (DIN 27) film, set ASA 50 (DIN 18) on your meter and get a direct reading for that film/filter combination (400 ÷ 8 = 50). This is a useful technique if you plan to keep the filter on the camera for a while and use it for a number of shots, or if you feel uncomfortable calculating exposure compensation in your head. Don't forget to reset the meter when you change filters.

If you want to calculate, then you can use the factor to find exposure compensation in terms of shutter speed. For example, if your meter gives you a reading of 1/250 sec. at f/11 and you are using a Medium Red (No. 25) filter with a factor of 8×, divide the shutter speed by 8 to get the compensated speed, which would be about 1/30 sec. The difficulty here is obvious. With deep-color filters, you get a shutter speed that is too slow for handheld work.

Most experienced photographers tend to think of exposure with filters in terms of an increase in f-stops, and translate factors into f-stops automatically. For example, a Medium Yellow (No. 8) correction filter has a factor of 2×,

which makes it a 1-stop filter; a Yellow-Green (No. 11) correction filter has a factor of 4×, which makes it a 2-stop filter; a Medium Red (No. 25) has a factor of 8×, so it is a 3-stop filter.

The accompanying chart gives filter factor equivalents in *f*-stops.

EXPOSURE INCREASE IN *f*-STOPS REQUIRED FOR FILTER FACTORS

Filter Factor	Exposure Increase to Nearest ½ *f*-Stop	Exposure Increase to Nearest ⅓ *f*-Stop
1×	No increase	No increase
1.2×	No increase	⅓
1.5×	½	⅔
2×	1	1
2.5×	1	1⅓
3×	1½	1⅔
4×	2	2
5×	2	2⅓
6×	2½	2⅔
8×	3	3
10×	3	3⅓
12×	3½	3⅔
16×	4	4

An individual case or pouch is usually provided with each new filter you purchase, but a pouch that holds several filters at a time is easier to use.

To keep your filters in order, label the case or pouch in which you keep each one. Put all relevant data on the label, including filter factor and exposure increase in f-stops, filter color or number, and other data you feel you might need.

Filter factors, or their equivalents in *f*-stops, are only guides to exposure. They are designed to give a good exposure of a neutral gray subject. The actual exposure required can vary, depending on the effect desired, lighting conditions, subject color, film used, exposure meter, and processing procedures. By and large, the factors are accurate, and you can't really go wrong by using them, but do not consider them as absolutes.

For ease in using filters, keep them in individual holders that are labeled with the filter name, number, exposure factor, and factor in *f*-stops. A piece of white masking tape will stick to almost anything and you can write on it with any handy pen, pencil, or crayon. Then cover the masking tape with a piece of transparent tape so that the writing will not rub off.

EXPOSURE WHEN COMBINING FILTERS

To find the exposure factor when using two or more filters, multiply filter factors. For example, if you combine a polarizer, which has a factor of about 3×, with a Medium Red (No. 25), which has a factor of 8×, the combined factor would be 24×. To find the compensation in *f*-stops, add up the extra stops required for each filter. The polarizer requires about 1½ additional stops and the Medium Red (No. 25) needs 3 stops more exposure. Combine them and you get a 4½-stop exposure increase.

2

Filters for Color Film

This chapter deals with ways to obtain pleasing color using filters. It tells you how to get natural flesh tones under cloudy skies, eliminate the reddish cast in photos taken by normal household light, and get rid of the blue-green tint that seems to plague color shots made under fluorescent illumination. In these and other situations covered, filtration is used to control color quality.

(The use of colored filters to achieve special effects with color film is covered at considerable length in Chapter 5, "Special Image Variations.")

Color slide films are particularly sensitive to variations in the quality of light. The sun hiding behind a cloud can turn a healthy complexion cyanotic in an instant, and the use of pale-colored filters can produce major changes. With color print films, changes are less obvious because variations in the color of the light on the scene are compensated for automatically by the printer.

In learning to use filters effectively in color photography, stick with fresh color slide film and use a reliable processor. (Bad processing can turn a roll of film blue or cover it with discolored splotches; film can also be damaged by heat and chemical fumes, including some inexpensive perfumes that contain formaldehyde.)

Fresh slide film—film that has not yet reached the expiration date marked on the package—will, when accurately processed, give you a clear idea of what filters are doing, or not doing, for you. To judge results, use a light box designed for viewing slides or a slide projector. A slide projector gives a slightly warmer look to slides than does a light box, so standardize on one source or the other. To determine quality, one method is to use a light box when the slides are to be reproduced in a magazine or book, and a projector when the slides are intended for projection. Don't try to judge color quality by holding a slide up to a window—the light is too blue.

To get a rough idea of how a particular filter might have improved, or wrecked, a shot, look at the slide through the filter. With a projector, just hold the filter in front of the lens. The result will not be quite what you would have gotten by filtering the shot in the first place, but the technique will give you an idea of what can be done.

Color prints do not give you a good idea of what filtration does. If like most people you have your color print film processed by a mass-production laboratory, your chances are about one out of five that the negatives will be printed correctly. The rest will have one defect or another—off color, poorly cropped, blurry—or some combination of defects. Don't bother to filter the Kodacolor II and Kodacolor 400 Films because the printing program takes into account variations in light sources. The automatic printer can also undo your attempts at special effects by "correcting" them to something that looks more "normal." If you do your own color printing, or have it done by a custom lab, then you might consider filtering some shots just to make them easier to print.

THE REASON FOR COLOR CORRECTION

In the first chapter, you learned that light is made up of a spectrum of colors running from ultraviolet through the visible range—blue, green, yellow, orange, red—to infrared.

The actual proportion of colors in light varies considerably, depending on the nature of the light source. As you might expect, if you are standing in open shade under a blue sky, the light around you is mostly blue. When you read by the light of a 100-watt bulb, the light is relatively red or reddish-yellow, although you may perceive it as white due to your ability to adapt readily to differing conditions.

Color film does not share human adaptability, although recent developments in color print films have resulted in automated printing systems with great tolerance for a variety of light sources. Technically, film is designed to give optimum performance in only one type of light. With daylight films, this optimum light is a mixture of hazy sunlight and skylight on a summer day around noon. High-quality electronic flash units produce a similar type of ideally balanced light. All other light mixes are wrong in some degree. For example, overcast daylight is too blue; sunlight around sunset is too reddish; and candlelight is so far off that the results look like a deliberate special effect.

Many years ago, a British scientist, William Thomson Kelvin, devised a scale for comparing the quality of different

COLOR TEMPERATURE OF COMMON LIGHT SOURCES

Source	Color Temperature (Kelvin Units)
Clear blue northern skylight	15,000–27,000
Open shade (subject illuminated by blue skylight)	10,000–12,000
Hazy skylight	7500–8400
Overcast sky	6700–7000
Electronic flash	6200–6800
Blue flashbulb	6000
Hazy sunlight	5800
Average daylight	5500–6000
A.M. or P.M. sunlight	5000–5500
500-watt blue photoflood	4800–5400
Clear zirconium foil-filled flashbulbs	4200
Clear aluminum foil-filled flashbulbs	3800
500-watt amateur photoflood lamps	3400
500-watt studioflood lamps	3200
100-watt general-service light bulb	2900
75-watt general-service light bulb	2820
40-watt general-service light bulb	2650

types of light. Unfortunately, the scale only takes into account the red and blue portions of the spectrum; it leaves out green light, which is essential for balanced color shots. Nonetheless, the Kelvin system is still used for want of anything better. It is called the color temperature scale and is broken down in degrees Kelvin. According to this scale, optimum daylight has a color temperature of 5500 K (K = Kelvin); a photoflood bulb has a temperature of 3400 K; a studioflood bulb, 3200 K; and a 100-watt light bulb, 2900 K. This is mentioned here only because people still refer to the color temperature for which a particular film is balanced, and sometimes a manufacturer's literature will tell you how to filter for various color temperatures. The system is virtually useless when you have to figure out filter combinations because it is not directly proportional. (More on this in Chapter 7.) Meanwhile, don't try to memorize color temperatures for various light sources; it won't do you any good. Just learn what filter to use in a handful of common situations and you will come out on top. The charts throughout this chapter summarize everything you really need to know about color filtration.

When you use a filter to correct or "balance" a light to match the optimum for a particular film, you are simply trying to get the various proportions of colors in the light to match that for which the film is designed. The term *balanced* refers to the fact that film is made up of three layers of light-sensitive emulsion, each designed to respond to a different portion of the spectrum. These three layers are balanced to produce natural-looking color under one standard light source. In addition to standard daylight, there is photoflood illumination, which is the standard for most Super 8 color films, and studioflood illumination, also called *tungsten* lighting, which is the standard for tungsten-type film, such as Kodak High Speed Ektachrome 160 Film, Tungsten. These are the three standards for color slide film worldwide. Color print films are also balanced for standard daylight.

Most Super 8 films are balanced for photoflood lighting, with the single exception of Kodak Ektachrome 160 Type G Film, which is balanced for an intermediate quality light somewhere between standard daylight and photoflood

Direct sunlight is harsh and produces unflattering portraits. Use of a fog filter diffuses the light and yields a white veil that gives the scene a soft, gentle mood appropriate to the subject. (Left) No filter; (below) No. 3 fog filter.

A single variable-color filter can produce a variety of effects, depending on the setting. To achieve the magenta color in the clouds and on the boat deck, a red/blue filter was set about midway between the two colors. (Left) No filter; (below) red/blue variable-color filter.

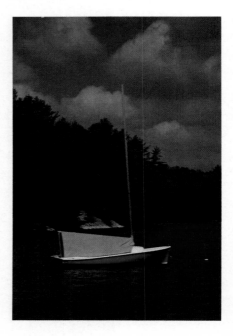

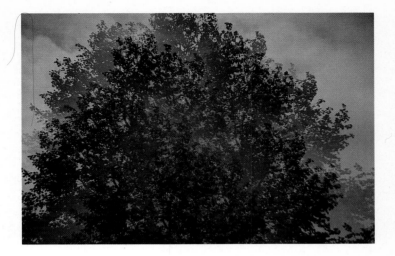

(Above) This "augmented tree" was produced by using a six-facet multiple-image prism plus a red/green variable-color filter set to the green position. (Below) The torch of the Statue of Liberty is an ideal subject for interpretation with a star filter. Because the star filter does not require additional exposure, it can be used at night for available-light photography with no loss of film speed.

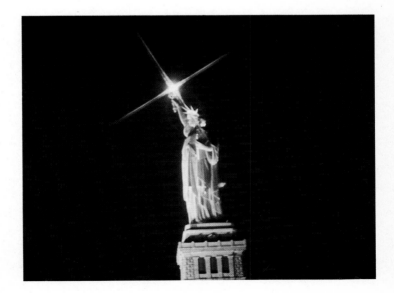

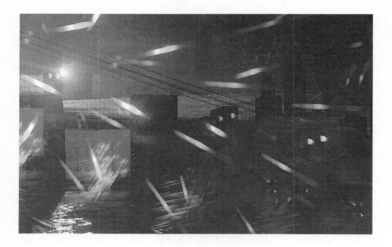

(Top) When special-effect filters are used in combination and the subject is one that works well in silhouette, dramatic results are almost guaranteed. Here the Brooklyn Bridge, backlighted by the sun, was photographed through two multiple-image prisms (six-facet and five parallel facet), plus a variable-color red/blue filter set to the maximum red position, plus a spectral-burst (holographic diffraction) type filter. Only the variable-color filter required an exposure increase—about two stops. (Bottom) This mustard jar was photographed through a five-facet multiple-image prism in conjunction with a +2 close-up lens; a normal lens was used on the camera.

Although designed for scientific applications such as aerial surveys, color infrared film can be used for variety and special effects in general pictorial photography. The effects achieved depend on the infrared reflectivity of the subject and on the filter used. Try ASA 100 as a starting setting for your meter and bracket exposures by one stop over and under to get a range of effects.

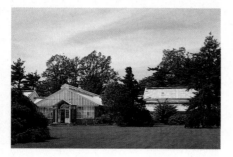

No filter.

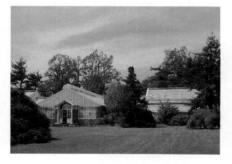

Yellow (No. 12) filter. This is the standard filter for use with color infrared film in all scientific applications.

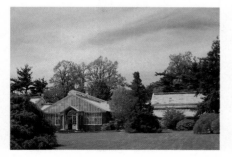

Medium Red (No. 24) filter turns the sky green and clouds yellow.

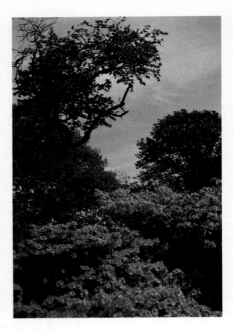

A sky-darkening or graduated neutral density filter can darken down a blue sky, increasing the saturation of the blue so that it becomes a vivid part of a color composition. (Right) No filter; (below) sky-control filter: half .6 neutral density, half clear.

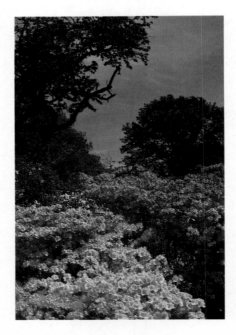

Fluorescent lights tend to produce odd greenish or blue-green color casts with most transparency films. One partial solution is to use a fluorescent light filter. (Above) No filter; (below) fluorescent light filter.

Daylight film used in tungsten lighting such as that provided by household lightbulbs or, as here, studio floods, takes on a reddish yellow cast unless an 80A conversion filter is used. (Above) No filter; (below) 80A conversion filter.

lighting. Type G is really a compromise designed for general amateur Super 8 moviemaking where color quality is not critical. If you use Type G, don't bother filtering, and don't expect high-fidelity color either.

SKYLIGHT AND UV FILTERS

The Skylight 1A, or "Sky," filter is still the most popular first filter purchased by photographers. Although not needed in most situations, those who use it argue that it does several important things.

First, it cuts out most of the ultraviolet (UV) radiation that can affect your photos. Strong UV radiation can create an overall bluish veil in color photos. UV can also produce a ghost image because most lenses are not designed to focus UV light in the same plane as visible light. In other words, on a clear day at the beach or high in the mountains, you might get a slightly unsharp secondary image, particularly if you are using an old, uncoated lens. With today's antireflection coated lenses, which absorb UV in much the same way as a Skylight filter, this ghosting is seldom a problem and bluish casts due to UV are eliminated in all but the most extreme conditions, such as high in the mountains.

Second, the Skylight filter helps partially correct the bluish cast on flesh when photographed in open shade and eliminates the faint bluish haze that sometimes plagues color photos made at high altitudes and from airplanes. In direct sunlight, it does not seem to have any noticeable effect, so its action is never a problem, simply a help in some situations.

Third, it makes a good lens protector for use at the beach or in dusty areas. If you use it as a transparent lens cap, remember to check it periodically for excessive scratches. There is the story of one photographer who thought his lens had developed problems because his pictures began to get gradually softer. It turned out he just hadn't bothered to remove his Skylight filter in several months and the filter had become badly scratched. (Because the filter is flush with the end of the lens, it is more liable to

get scratched than the front element of the lens itself, which is slightly recessed.)

In most situations, you do not need a Skylight filter. And since its correction is only partial, you may prefer to use either no filtration or stronger filtration designed to give more complete correction.

Slightly stronger filtration with additional warmth is provided by such filters as Tiffen Haze 1 and Haze 2. Hoya Skylight 1B filters out some of the excess green from pale flesh tones in outdoor shots made in grassy surroundings.

UV filters are faintly yellow and yield progressively greater effects. They are especially useful for haze penetration when photographing distant subjects through long telephoto lenses and making aerial photos from airplanes and helicopters. UV filters help reduce blue in open shade. Although their transmission characteristics vary somewhat from those of light-balancing filters, which are discussed below, the yellowish UV filters can be used effectively to warm light that is too bluish. They also have applications in scientific and aerial photography because of the precise nature of the cutoff point in the UV, or blue, region of the spectrum. A Tiffen UV 16 reduces excessive blue in electronic flash units that are not color corrected.

No exposure increase is required for Skylight or UV filters.

MAJOR CORRECTIONS

Conversion filters are designed to handle major differences between the existing light in a scene and the standard light for which the film is balanced. For example, if you want to get natural-looking flesh tones in a portrait made with studiofloods and daylight-type slide film, such as Fujichrome or Kodachrome 64, use a blue conversion filter. This is an 80A filter in the United States, but goes by other names elsewhere. It is deep-blue and in manufacturers' literature is described as converting 3200 K light to 5500 K. It has a factor of 4× or 2 f-stops.

To convert photoflood light for use with daylight film, use an 80B filter on your lens. It has a factor of about 3.2× or 1⅔ f-stops.

Household light bulbs are considerably warmer in color than either photofloods or studiofloods, so an 80A or 80B filter will produce only partial conversion and your results will still be slightly on the reddish-yellow side. On the other hand, full conversion will produce an artificial look. After all, even though people adapt to changes in light and don't see light bulbs as throwing off yellow light, they do sense it as being warm. If you take a picture of a subject illuminated by any type of tungsten light and fully correct, so that it looks as though the photo were made in standard daylight, the results may seem wrong—too blue to be true to life. Full correction is used mostly for product photography, in which colors are supposed to be fully saturated and as sparkling and pure as possible, and for portraiture, where the standard for reproducing skin tones is standard daylight.

You may occasionally run across two other deep-blue conversion filters, the 80C and 80D, which were formerly used to balance clear flash with daylight. Since clear flash is a thing of the past in most places, you will probably never have use for either one, although you could combine an 80D with an 80A and produce nearly complete conversion of a 100-watt light bulb to daylight quality. The combined exposure factor would be about 2½ f-stops. (Filter combinations are discussed in more detail later in this chapter.)

CONVERSION FILTERS FOR COLOR FILM

Film Type	Application	Lighting Conversion	Filter No.	Exposure Increase in f-Stops
Daylight	With studiofloods and general-service light bulbs	3200 K to 5500 K	80A	2
	With photofloods	3400 K to 5500 K	80B	1⅔
Type A	With daylight: general use	5500 K to 3400 K	85	⅔
Tungsten	With daylight: general use	5500 K to 3200 K	85B	⅔

35

Amber-colored conversion filters are used to balance daylight or electronic flash light with indoor film. A No. 85 filter lets you use Type A Super 8 film with daylight. (It converts 5500 K light to 3400 K, or photoflood quality.) It has a factor of about 1.5× or ⅔ f-stop. A No. 85B filter lets you use tungsten-type film, such as High Speed Ektachrome 160 Tungsten, in daylight or with electronic flash. It has a factor of about 1.5× or ⅔ f-stop. (It converts 5500 K light to 3200 K, or studioflood quality.) If indoor film is shot in daylight without filtration, it will produce a strong overall blue cast.

When you use an amber-colored conversion filter on the front of a through-the-lens metering camera, you may find that the meter underexposes by about ½ f-stop because it is more sensitive than the film to the reddish light passed by the filter. If this happens, try adjusting your ASA downward about 25 percent. For example, with High-Speed Ektachrome 160 Tungsten (ASA 160), try setting your camera meter at ASA 125 when you have an 85B conversion filter in place on your lens.

Most Super 8 film is Type A, and most Super 8 and Single 8 cameras have a built-in conversion filter that always remains in place inside the camera unless you screw some other device into the movie-light socket or press a special filter button on the camera. Leaving the filter button depressed keeps the conversion filter out of the light path, and if you do this while filming in daylight, the result will be film with a strong overall blue cast. Failure to press the filter button or to screw a device into the movie-light socket when filming by tungsten light will produce a reddish cast.

MINOR CORRECTIONS

Small changes in the quality of light striking the film can be made using light-balancing filters. These pale filters are used most often for outdoor portraiture and fashion photography because these situations require accurate color rendition and because the appearance of truly standard daylight is a rare event. Light-balancing filters are also used in scientific and industrial photography for balancing special light sources.

There are two sets of light-balancing filters: the

bluish 82 series is used to cool the light; the yellowish 81 series is used to warm the quality of light. Most manufacturers worldwide have adopted the same nomenclature for these filters; however, some use another system, called the *DecaMired system*, which is based on a modified color temperature scale. The DecaMired system is described in Chapter 7, where you will also find a chart showing the equivalent light-balancing filter.

Technically, light-balancing filters are designed to make precise changes in tungsten lighting. The fact that they are now used primarily for making changes in the quality of daylight, in professional motion-picture photography, and in some scientific applications is the result of changing technology. There was a time when they were used extensively in photo studios—in the days before electronic flash and quartz lighting became standard—because photoflood and studioflood bulbs changed color with age and it was necessary to make constant adjustments as the lights burned in order to retain optimum color quality. Today's quartz lights do not change color with age, and professional electronic flash units are balanced to provide standard daylight-quality light. As a result, light-balancing filters are seldom needed in the studio. But they are often used in the field for outdoor photography.

Of all the light-balancing filters available, the 82A is the most useful because it produces natural-looking flesh tones when you use daylight color slide film under overcast skies. If you like a slightly warmer tone in your shots, try the 82B. You can use an 82C to warm flesh tones in portraits and fashion shots made in open shade under blue skies.

Occasionally, you will run across a filter called the "cloudy" filter, which is a Japanese equivalent of an 81A. This filter provides very slight warming and won't do much damage to your sunlight shots if you forget to take it off. Many photographers prefer it to the Skylight 1A; however, personal preferences vary, so experiment with various filter and light combinations before you settle on one.

To cool off the reddish light of the sun late in the afternoon, try the bluish 82, sometimes called the "morning/ evening" filter. If that does not produce enough of a color shift, try the slightly denser 82A.

To convert 3400 K photoflood light to studioflood (3200 K) quality for use with tungsten film, try an 81A filter. To convert studioflood to photoflood quality light required for Super 8 films, use an 82A.

If 100- or 75-watt household light bulbs are producing results which you feel are too warm, and you are using tungsten-type film without filter or daylight-type film with an 80A conversion filter, try adding an 82B light-balancing filter and giving ½ to ⅔ f-stop additional exposure.

No exposure increase is ordinarily required with 81, 81A, 81B, and 81C filters, although if exposure is critical you can use ⅓ f-stop additional exposure. The two strongest filters in the yellowish series of light-balancing filters are the 81D and 81EF, both of which require ½ f-stop additional exposure for general work or ⅔ f-stop more exposure for critical work.

You may have noticed that the author is somewhat cavalier about recommending exposure increases. This is because the difference between ½ and ⅔ f-stop is usually insignificant, and it is much easier on most lenses to find ½ stops exactly than it is to find ⅓ and ⅔ f-stops. As a rule of thumb, if the filter factor amounts to ⅓ stop or less, forget it; if it comes to ⅔ stop, translate that to mean ½ stop. With important shots where color is critical, you should bracket

EXPOSURE FACTORS FOR LIGHT-BALANCING FILTERS

Filter Color	Filter No.	Exposure Increase in f-Stops
Blue	82	⅓
	82A	⅓
	82B	⅔
	82C	⅔
Amber	81	⅓
	81A	⅓
	81B	⅓
	81C	⅓
	81D	⅔
	81EF	⅔

both exposure and filters, making a number of shots at different settings with different filters. If you are a professional, do whatever it takes to get the job done right.

No exposure increase is required with the 82 and 82A filters, although ⅓ f-stop is recommended by Kodak as a starting point for critical work. Use an increase of ½ f-stop with the 82B and 82C filters, or ⅔ f-stop for critical work. The accompanying chart shows the exposure increase in f-stops required for light-balancing filters. To find exposure compensation when these filters are used in combination, add the exposure increase in f-stops for each filter.

LIGHT BALANCING AND CONVERSION FILTER SELECTOR CHART*

Film Type	Light Source								
	Open shade (bluish daylight); slight overcast; blue flashbulbs	Electronic flash that produces a blue cast	Cloudy; heavy overcast	Blue skylight	Average sunlight plus skylight	Early A.M. or late P.M. sunlight	3400 K photofloods	3200 K studiofloods	100-watt light bulb
Daylight	81A	81B	81B	81C	None	82 or 82A	80B	80A	80A + 82A
Exposure Increase in f-Stops	⅓	⅓	⅓	⅓		⅓	1⅔	2	2⅓
Type A (Most Super 8 films and Kodachrome Type A)	85 + 81A	85 + 81B	85 + 81B	85 + 81C	85	85C or (81D + 81D)	None	82	82B
Exposure Increase in f-Stops	1	1	1	1	⅔	⅓ or 1⅓		⅓	⅔
Tungsten (Type B—balanced for 3200 K)	85B + 81A	85B + 81B	85B + 81B	85B + 81C	85B	85	81A	None	82A
Exposure Increase in f-Stops	1	1	1	1	⅔	⅔	⅓		⅓

*The above recommendations should be considered only as starting points for bracketing. In critical situations, pretest.

39

SUMMARY OF TYPICAL COLOR PROBLEMS AND CORRECTIVE PROCEDURES

Problem	Probable Cause	Correction
Bluish color cast	Tungsten-type or Type A film used in daylight or with flash without filter	Use appropriate conversion filter
	Photograph made on daylight-type film in open shade, at twilight, or under overcast skies	Use Skylight 1A for general correction Use 81 series of light-balancing filters for greater correction
Dense cyan cast on film	Faulty processing or photograph made through a cyan filter	None
Reddish or yellow color cast	Daylight-type film exposed by tungsten light or clear flash	Use appropriate conversion
	Film balanced or converted to 3400 K or 3200 K light exposed by general household light bulb	Use 82C or B3
Green or blue-green color cast	Film exposed by fluorescent lights	Use FLD filter for daylight films; use FLB filter for tungsten films; or use suggested CC filter
	Local color cast due to green foliage	Use Color Compensating filter as required
	Film correctly exposed; no local color cast	Improperly aged film; processing error Color Compensating filters may be tested as possible means for correction
	Reciprocity failure due to exposures longer than those for which film is designed	Expose according to manufacturer's recommendations; use filters recommended by manufacturer to compensate for reciprocity failure
	Film subjected to heat or chemical vapors during storage	None

FLUORESCENT LIGHT FILTERS

The blue-green cast that most fluorescent lights give to color film is a special problem. Visually, people do not actually perceive fluorescent light as being anything other than white.

The strange color cast that fluorescents give to color film is due to the fact that most fluorescent bulbs used in homes and offices have a discontinuous spectrum, which means that the light has an abundance of some colors but is missing others entirely.

A number of manufacturers now offer filters said to provide general correction for fluorescent lighting. Often called FLD filters, they are supposed to bring the light into line with daylight-type films. (The FLB filters are for use with tungsten-type [indoor] films.)

Unfortunately, because there is a bewildering variety of fluorescent lights in common use today, each with its own unique characteristics, the results with fluorescent correc-

COLOR-COMPENSATING FILTERS FOR CORRECTION WITH FLUORESCENT LIGHT

Film Type	Light Source					
	Daylight	White	Warm white	Warm white deluxe	Cool white	Cool white deluxe
Daylight	40M + 30Y	20C + 30M	40C + 40M	60C + 30M	30M	30C + 20M
Exposure Increase in *f*-Stops	1	1	1	1⅔	⅔	1
Tungsten	85B + 30M + 10Y	40M + 40Y	30M + 20Y	10Y	50M + 60Y	10M + 30Y
Exposure Increase in *f*-Stops	1	1	1	⅓	1⅓	⅔
Type A	85 + 30M + 10Y	40M + 30Y	30M + 10Y	No filter	50M + 50Y	10M + 20Y
Exposure Increase in *f*-Stops	1	1	1		1⅓	⅔

tion filters tend to be too reddish in many situations. Yet they may be better than nothing at all. Short of using a special Tri-Color temperature meter, there is really no way of knowing what you need without testing various filter combinations. If you are a pro, you should test, providing you have time, because you owe it to your client. Alternatively, a pro can bracket filtration, trying an FLD and several combinations of the Color-Compensating filters suggested in the accompanying chart. (Color-Compensating filters are discussed below.)

Some photographers like to use a CC30R filter for general compensation with fluorescents. Others may prefer an 81EF, which is the strongest of the light-balancing filters.

Some fluorescents are suitable for use with daylight color film without filtration. One readily available type is the Vita-Lite #481, which is sold as a light for house plants. It is supposed to help plants grow, but it also makes a good diffuse light for color photography.

COLOR-COMPENSATING FILTERS

Color-Compensating (CC) filters are available in varying densities of red, yellow, blue, green, cyan, and magenta. The other filters covered earlier in the chapter are designed for general corrections and affect a number of different colors at the same time. CC filters are highly specific, pure-color filters. By using them in combination, you can make very precise adjustments to compensate for such things as batch-to-batch variations in the quality of color slide and motion-picture film. They can also be used in the darkroom for color printing and for altering color quality when making duplicate slides.

A common use of CC filters is to correct for reciprocity failure, which is the tendency of color films to change color balance during extremely long exposures. Film manufacturers generally supply recommended combinations of CC filters for reciprocity correction with each film type and exposure range. For example, Kodachrome 25 requires the use of CC10M for correct color balance with exposures of 10 seconds.

Color-Compensating filters are identified by depth of

EXPOSURE GUIDE FOR
COLOR COMPENSATING FILTERS

Peak Density	Yellow (Absorbs Blue)	Exposure Increase in Stops*	Magenta (Absorbs Green)	Exposure Increase in Stops*	Cyan (Absorbs Red)	Exposure Increase in Stops*
.025	CC025Y	—	CC025M	—	CC025C	—
.05	CC05Y	—	CC05M	1/3	CC05C	1/3
.10	CC10Y	1/3	CC10M	1/3	CC10C	1/3
.20	CC20Y	1/3	CC20M	1/3	CC20C	1/3
.30	CC30Y	1/3	CC30M	2/3	CC30C	1/3
.40	CC40Y	1/3	CC40M	2/3	CC40C	2/3
.50	CC50Y	2/3	CC50M	2/3	CC50C	1

Peak Density	Red (Absorbs Blue and Green)	Exposure Increase in Stops*	Green (Absorbs Blue and Red)	Exposure Increase in Stops*	Blue (Absorbs Red and Green)	Exposure Increase in Stops*
.025	CC205R	—		—		—
.05	CC05R	1/3	CC05G	1/3	CC05B	1/3
.10	CC10R	1/3	CC10G	1/3	CC10B	1/3
.20	CC20R	1/3	CC20G	1/3	CC20B	2/3
.30	CC30R	2/3	CC30G	2/3	CC30B	2/3
.40	CC40R	2/3	CC40G	2/3	CC40B	1
.50	CC50R	1	CC50G	1	CC50B	1 1/3

*These values are approximate. For critical work, they should be checked by practical test, especially if more than one filter is used.

STARTER SET FOR COLOR PHOTOGRAPHY

Filter Type	Filter No.
Skylight	1A or 1B
Light-balancing (warming)	81A
Light-balancing (cooling)	82A
Polarizer	
Fluorescent light, daylight	(FLD or FD or CC30M)

color (density) and by color. For example, in the CC30R designation, the CC stands for Color-Compensating, 30 for a density of 0.30, and R for red. The accompanying chart shows the usual range of CC filters and the exposure increases required for each density.

To use CC filters effectively in general photography, a Tri-Color temperature meter is considered essential. This meter measures the red, green, and blue portions of the spectrum and gives readouts in either light-balancing or CC filter values. A three-color meter can be used to measure daylight, fluorescent light, and tungsten light. Unfortunately, they cost more than most top-quality 35 mm SLRs, which probably accounts for the fact that they are used almost exclusively by commercial photographers and motion-picture cameramen. (Two-color meters are much less expensive, but they measure only tungsten light and so are almost useless in the modern studio.)

A full set of CC filters is also expensive and is likely to be found only in the best-equipped studio. The one filter that seems to have wide use in this series is the CC30R, which is used underwater to provide full or partial color correction, depending on the water quality, depth, and lighting. It is used for underwater photography because water absorbs red very rapidly, and by the time a diver is ten feet beneath the surface, the red rays are almost gone. The CC30R may also be used to correct color distortion when photographing through tinted windows, such as the vistadomes on some railroad cars.

CC filters can also be used to correct for various combinations of fluorescent lights, as shown in the chart accompanying the section on fluorescent lighting.

3

Filters for Black-and-White Film

Filters for use with black-and-white films are brightly colored and give photographers cheerfully beguiling views of the world when placed on the lens of an SLR. Unfortunately, the visual jolt as you first look at a deep woods through a green filter or at a mountain range through a red filter is a response to color, and the final print is of course black-and-white. The effect of using these filters with color films is discussed in Chapter 5, "Special Image Variations." For now, the emphasis is on the use of filters to make selected colors appear as tones that are lighter or darker than normal in the finished print.

There are two basic reasons for using filters in black-and-white photography. The most important is to improve the separation among tones in the image. Tone separation, also called *contrast*, is the degree to which one area of the image is lighter or darker than another. An example is darkening a blue sky with clouds in it. Unfiltered, the blue sky appears almost white and the clouds are lost in a normally exposed image. When you use an orange or red filter for the same scene, however, the blue sky is darkened and the clouds stand out dramatically.

Another function of filtration is tone correction, which involves the use of a filter to make up for the difference between the way the eye responds to colors and

the way today's black-and-white films respond. This is one area which beginning photographers ignore and probably shouldn't.

FILTER EFFECTS ON BLACK-AND-WHITE PRINTS

Color	Effect in Final Print
Yellow	Lightens yellow; some lightening of red and green; darkens blue; helps penetrate haze
Orange	Lightens red and orange; excellent haze penetration; darkens blue
Red	Lightens red; darkens blue and green; excellent haze penetration
Green	Lightens green; darkens red and blue
Blue	Lightens blue; accentuates haze; darkens yellow, green, and red

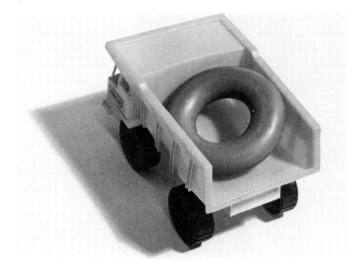

The bed of this toy truck is red, the cab yellow, and the big "O" green. Without filtration, there is almost no separation between cab and truck bed and the "O" does not stand out well.

A Dark Green (No. 58) filter dramatically darkens the red truck bed and lightens the big green "O". The yellow cab is just slightly darker than in the unfiltered shot because yellow is a combination color that contains a significant amount of green, which passes easily through the green filter.

A Medium Red (No. 25) filter turns the big green "O" almost black and makes the red truck bed extremely light. The yellow cab is lightened only slightly because the red filter holds back the green of the yellow.

THE FOUR BASIC FILTERS

In black-and-white photography, there are only four filters that are really important, although knowing about the effects you can get with some of the others may be an aid to getting more imaginative photos. The four are: Medium Yellow (No. 8) correction filter, also called a K2 by some manufacturers; Dark Yellow (No. 15) or Orange (No. 16) contrast filter; Yellow-Green (No. 11) correction filter; and Medium Red (No. 25) contrast filter.

The Medium Yellow (No. 8), or K2, is the standard daylight correction filter. Today's general purpose panchromatic films, such as Kodak Tri-X, Plus-X, and Panatomic-X, or Ilford HP-4 and FP-4, are a bit too sensitive to blue and slightly insensitive to red, so that blues reproduce too light and reds too dark. In practice, this means that blue skies and water will be unnaturally light whereas reds and greens will be on the dark side relative to neutral colors, such as weathered wood.

The Medium Yellow filter also absorbs UV radiation, which can cause a slightly unsharp appearance in photos taken at very high altitudes, particularly above 1830 meters (6000 feet). It is useful when photographing snow scenes, where shadows may be too light because of the large amounts of blue light reflected by the snow. It may also be used in outdoor portraiture and fashion photography, particularly when a blue sky is used as a background. The Medium Yellow filter lightens blond hair and fair complexions, darkens blue eyes, and helps subdue freckles. It can also be used to bring out detail in wood and foliage, although a deep-yellow filter will do a better job in most cases. Because the color is actually a combination of red and green, the yellow filter passes green light freely. As a result, it lightens foliage slightly.

The Medium Yellow, or K2, has a factor of 2× in daylight, which means you will have to open up 1 f-stop when you use it.

With very pale complexions, the action of the yellow filter may be too strong, in which case use the Yellow-Green

(No. 11). The Yellow-Green (No. 11) is an ideal outdoor filter for black-and-white portrait photography. It improves the rendition of all flesh tones, regardless of race, and darkens a blue sky sufficiently to give it a natural appearance. This filter helps separate delicate shades of green, such as buds and grasses in springtime, and is recommended for careful landscape work and flower photography. Outdoors, the Yellow-Green (No. 11) has a factor of 4×, which means opening up 2 f-stops. A two-stop

FILTERS FOR BLACK-AND-WHITE GENERAL-PURPOSE FILMS*

Filter Color and Wratten No.	Suggested Use	Exposure Increase in f-Stops (Daylight)
Light Yellow (6)	Partial correction; slight haze-penetrating effect	$^2/_3$
Medium Yellow (8)	For correct tonal rendition of foliage, sky, and clouds	1
Yellow-Green (11)	For correct tonal rendition in tungsten light. Lightens foliage in landscape photos	2
Yellow-Green (13)	Similar to No. 11. Correction filter in tungsten light for films with high green sensitivity	$2^1/_3$
Dark Yellow (12)	A minus blue filter. The standard for color infrared. Good haze penetration in aerial photography. Sky darkening	1
Dark Yellow (15)	Darkens sky in landscape photos. A good general-use sky-darkening filter. Also for marine scenes. Use for copying yellowed documents. Passes most green	$1^2/_3$

FILTERS FOR BLACK-AND-WHITE GENERAL-PURPOSE FILMS*

Filter Color and Wratten No.	Suggested Use	Exposure Increase in *f*-Stops (Daylight)
Orange (16)	Provides slightly greater sky darkening than the Dark Yellow. Good for penetrating haze in telephoto and aerial photography. Absorbs some green	$1\frac{2}{3}$
Dark Orange (21)	Strong sky darkening. Absorbs blue-green and green. Provides improved contrast in marine scenes	$2\frac{1}{3}$
Light Red (23A)	Used for sky darkening. Improves detail with all-red subjects. Absorbs green	$2\frac{1}{2}$
Medium Red (25)	Popular filter for dramatic sky darkening. Absorbs blue and green. Used with black-and-white infrared film. A color-separation filter	3
Dark Red (29)	A color-separation filter. Provides stronger sky darkening than the medium red	4
Light Blue (38)	Used to correct tendency of reds to reproduce too lightly in tungsten illumination	
Dark Blue (47B)	Color-separation filter. Also used to lighten blue; emphasize haze; create feeling of nineteenth-century photos	3
Light Green (52 or 56)	Used to lighten greens in landscape photography. Darkens blues and reds	$2\frac{1}{2}$
Dark Green (58)	Color-separation filter. Absorbs red and blue	3

*These are the filters most commonly used in general-purpose photography. Many others are used in scientific and technical work.

loss can be significant when you are using a handheld camera and slow film, which is one good reason photographers find not to use it. But remember that the right filter can give your photos a snap that they might not get any other way.

The Yellow-Green (No. 11) is also the recommended correction filter for tungsten lighting (household light bulbs, studiofloods, and photofloods). Without correction, the reddish tungsten light results in green plants that are too

dark, and red clothing, lips, and flesh tones that are too light. Proper tonal balance is achieved using the green correction filter. It has a factor of 3× in tungsten light, which means opening up 1½ f-stops. Use it for portraits and in situations where correct tonal relationships are important, such as photographing art for archival purposes.

The Dark Yellow (No. 15) and/or Orange (No. 16) filters are used to improve contrast, cut through haze for a sharper view of distant subjects, and generally give a picture more snap and sparkle. Most photographers will select either the Dark Yellow (No. 15) or the Orange (No. 16) filter; there is no need to own both (however, the Orange will have a slightly stronger effect).

These filters darken blue skies dramatically, and in clear areas, such as deserts and mountains, give you as much sky darkening as you can normally afford without having the results look faked.

The Dark Yellow (No. 15) has about the same haze-penetrating ability as the human eye. This means that if you can see detail in a distant subject, such as trees on a mountainside, the detail should appear in the photo, despite the presence of haze and other particles in the atmosphere. Unfiltered shots of distant subjects are frequently veiled as a result of the scattering of blue light by particulate matter in the air. The effect is called *aerial perspective*, which refers to the fact that the more distant a subject is, the lighter and

A Dark Yellow filter transmits infrared, red, and green—a combination that we perceive as yellow. It absorbs blue and ultraviolet light.

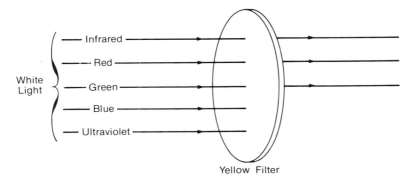

White Light
Infrared
Red
Green
Blue
Ultraviolet

Yellow Filter

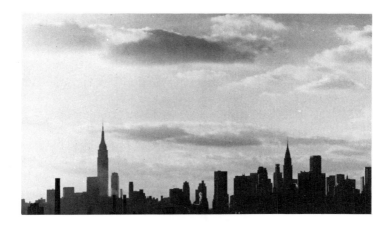

An Orange (No. 16) filter helped darken the sky and produce a dramatic mood for this cityscape by Julie Lomoe-Smith.

more veiled its appearance. Both Dark Yellow (No. 15) and Orange (No. 16) can be used for aerial photographs when perfectly correct tonal relationships are not required and the exposure factor required is not important.

Many experienced photographers use a Dark Yellow (No. 15) or Orange (No. 16) filter as a matter of course when photographing landscapes and architectural subjects with a telephoto lens. These filters help bring out the texture of sand, snow, and rock by holding back some of the blue in the shadows. They add sparkle to marine scenes because whitecaps and foam appear light in contrast to the water. They will help bring out the grain pattern in yellowish wood and improve the rendition of wet bark and fall foliage.

On the other hand, these filters are a poor choice when photographing people because faces, particularly those of persons with pale complexions, tend to look chalky and lips come out much too light.

Both the Dark Yellow (No. 15) and Orange (No. 16) have a factor of 2.5× in daylight, which means opening up 1⅓ f-stops. In tungsten light, they have a factor of about 1.5× to 2× or ½ to 1 f-stop. The difference in exposure factors is

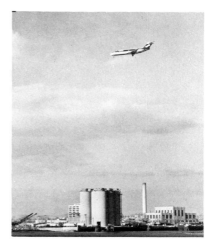

(Right) This plane coming in for a landing would have been lost against the light, smoky-blue sky if a Medium Red (No. 25) filter had not been used. (Below) The red filter transmits light of its own color—red—plus invisible infrared. It absorbs green, blue, and invisible ultraviolet. The absorbed light is radiated away in the form of heat.

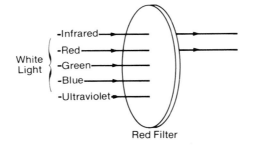

Red Filter

due to the fact that tungsten is rich in red and yellow light, which these filters pass freely.

The Medium Red (No. 25), or Red 1, is actually a color-separation filter that holds back all but the red bands of the spectrum. In general photography, it is widely used to create dramatic effects because it turns blue skies and stormy water dark gray. In contrast, it makes red subjects very light when compared to a neutral gray. With normal exposures, it tends to darken green foliage and turns pine trees almost black; however, in some situations green foliage may actually be lightened, particularly if you overexpose, because plants reflect a substantial amount of invisible infrared light, to which most black-and-white films are sensitive.

53

54

The Medium Red filter will render yellow objects lighter than blue or green materials because yellow is made up of both red and green light and red dominates. On the other hand, it will render yellow subjects darker than red ones. Flesh tones are unnaturally light when this filter is used to photograph people.

The haze-penetrating ability of the red filter is excellent.

The Medium Red is recommended for use with black-and-white infrared film, which has applications for both scientific and pictorial photography. (Infrared is covered in more detail in Chapter 5, "Special Image Variations.") A Medium Red filter/infrared film combination produces very dramatic landscapes in which blue skies are black, foliage appears almost white, and aerial perspective due to light haze seems to disappear.

The Medium Red is a three-stop filter with most black-and-white films in daylight, which means that it has an exposure factor of 8×. The factor in tungsten light is less—5× or 2⅓ f-stops with general-purpose films. The factor with high-speed recording films is even lower because these films are very sensitive to red light. Check the manufacturer's recommendations packed with the film to be certain.

ADDITIONAL YELLOW, ORANGE, AND RED FILTERS

There are several yellow filters that are similar in appearance to the Medium Yellow correction filter but are slightly weaker or stronger. The weaker filters, such as the

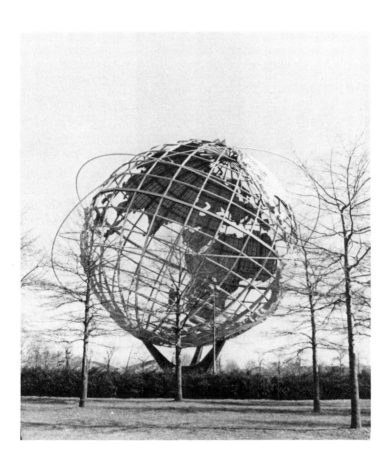

A Medium Yellow (No. 8) filter provides normal rendition of sky brightness.

Light Yellow (No. 6) and the Aero 1 (No. 3), require less exposure compensation but still absorb excess blue and UV radiation, darken skies slightly, and help penetrate haze. They have an exposure factor of 1.5×, which requires opening the lens ⅔ ƒ-stop (½ ƒ-stop is plenty).

The Light Yellow filter is used when correction is needed but maximum film speed is also a must, which is frequently the case when photographing sports, taking

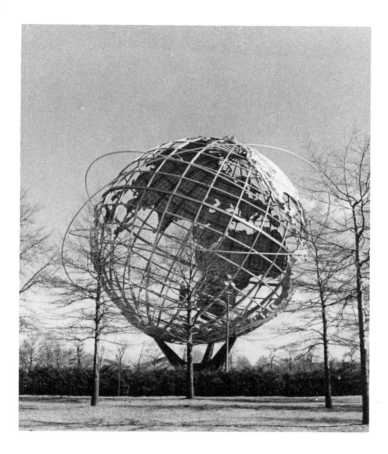

The Dark Yellow (No. 15) filter significantly darkens blue sky and brings out the clouds. In this photo, as in the others in this series, the values of the globe, which is neutral gray, remain unchanged.

pictures from light planes and helicopters, or photographing high in the mountains where excess blue is reflected from snow and rocks, making them appear unnaturally light.

A slightly darker Yellow filter (No. 9) provides greater sky darkening and haze penetration than the standard Medium Yellow correction filter. It has a factor of 2× or 1 *f*-stop exposure increase.

An even deeper yellow filter, Dark Yellow (No. 12), is

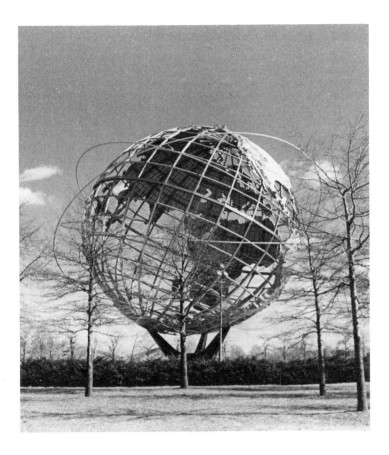

Dramatic sky darkening is provided by the Medium Red (No. 25) filter.

actually a pure yellow, which means that it passes only red and green light while ultraviolet and blue light are cut out. It is used in aerial and astrophotography to eliminate the blue wavelengths that can prevent clear recording due to their tendency to scatter as they hit particles in the atmosphere. The longer red and green wavelengths of light penetrate the atmosphere more effectively and provide a clearer image of distant subjects. The Dark Yellow (No. 12) has a factor of 2× or 1 f-stop exposure increase.

The Dark Yellow and Orange filters have already been discussed. However, you may occasionally encounter an even darker orange filter, Dark Orange (No. 21), which absorbs blues and blue-greens completely. It has a powerful haze-penetrating effect. It is used for seascapes and other subjects where strong suppression of blues is required. It has a factor of 6× or 2⅔ f-stops.

In addition to the Medium Red (No. 25), there is a Light Red (No. 23A) contrast filter, which is used to darken foliage, sky, and water and to bring out the detail in red subjects, such as brick buildings. It is used principally in architectural, scientific, and museum photography. The Light Red filter is particularly useful when you want to record subtle details in a red subject, such as the grain pattern in rosewood or the markings on a clay tablet.

The Dark Red (No. 29), or F, filter is even stronger than the Medium Red. It has an extreme effect on blue skies, turning them nearly black. This primary-color filter is intended as a filter for copying and color-separation work in color printing (see also Chapter 6). It is ideal for copying blueprints. The Dark Red has a factor of about 22× or 4⅓ f-stops.

GREEN FILTERS

There are two yellow-green filters, the Yellow-Green (No. 11) correction filter, discussed earlier, and its slightly darker companion, the Yellow-Green (No. 13), which is used principally for black-and-white portraits of men. Some photographers have successfully used the No. 13 for portraits of dark-skinned women.

The Yellow-Green (No. 13) has a factor of 5× in daylight (2⅓ f-stops) and 4× (2 f-stops) in tungsten light. Occasionally, it is recommended as a correction filter with films that are highly sensitive to green. The film manufacturer will usually specify the correct filter to use in the literature that comes with the film.

The Light Green (No. 56) also darkens sky and provides good flesh tone rendition, but absorbs more blue and red than the Yellow-Green (Nos. 11 and 13) correction

filters. It is especially well suited to separating out the delicate shades of green in a spring landscape; however the Yellow-Greens will also serve this purpose. The Light Green has a factor of 6× (2⅔ f-stops) in both daylight and tungsten light.

The Dark Green (No. 58) is designed for making color separations directly from original subjects. (For more on color separation, see Chapter 6.) In general photography, it can be used as a contrast filter to lighten foliage and darken red objects. It is also used to improve contrast in micrography and other scientific applications. The Dark Green has a factor of 8× (3 f-stops) in both daylight and tungsten light.

BLUE FILTERS

Blue filters have limited use in black-and-white photography and are used principally in scientific work. However, there are two that you should know about.

The Light Blue (No. 38) is sometimes recommended for correcting a tendency for reds to reproduce too lightly in tungsten illumination. It has a factor of about 1.5× or ⅔ f-stop.

The Dark Blue (No. 47B) is a tricolor filter used for making color-separation negatives from most subjects. It can be used in copying to eliminate blue lines from artwork and graphs and in general photography to simulate the effect of nineteenth-century materials, which were sensitive only to blue light. The Dark Blue filter has a factor of 8× (3 f-stops) in daylight and 16× (4 f-stops) in tungsten light.

A Dark Blue filter can be used to increase the effect of fog and mist in the air. It turns reds very dark, and flesh tones may come out swarthy if this filter is used for portraiture.

TIPS ON USING FILTERS WITH BLACK-AND-WHITE FILMS

As a rule, the effect of a filter is stronger if you underexpose slightly. (But underexposure leads to loss of detail in the shadows.) If you are trying to improve detail rendition with

a subject that is the same color as the filter, use a slightly lower filter factor than the ones given in this chapter. For example, if you are photographing a red pot against a white background in a museum with tungsten lights, you can get away with using a factor of about 3× (1½ f-stops) or 4× (2 f-stops) with a Medium Red (No. 25) filter, which normally has a factor of 6× in tungsten light. The best factor will vary slightly, depending on the film you use and the subject. Test or bracket exposures to be certain of good results.

STARTER SET FOR BLACK-AND-WHITE PHOTOGRAPHY

Filter Color and Wratten No.	Other Designations
Medium Yellow (8)	Yellow; K2
Yellow-Green (11)	Green X1
Dark Yellow (15)	Orange; G
Medium Red (25)	Red; A

Don't filter unnecessarily. Frequently, unfiltered results are better than shots that have been filtered indiscriminately, particularly when it comes to photographing multihued subjects, such as paintings. With most subjects, use a correction filter, UV filter, or none at all. Contrast filters should be used with specific results in mind, for example, sky darkening or improvement of detail rendition.

In addition to the colored filters covered up to this point, a group of variable-color filters is also available. These filters usually consist of a polarizer plus a colored element. By rotating one of the elements, you can change the color of the filter. These filters can be used as contrast filters in general black-and-white photography or as special-effect filters for color photography. They are discussed further in Chapter 5, which deals with special effects.

Variable-color filters have fairly high filter factors because they combine color with polarization. Moreover, you never know exactly how much correction or contrast you are getting. On the other hand, if you shoot mostly color and like these filters for special effects, you might consider letting them do for your filtration needs in black-and-white as well.

4

Polarization and Diffusion

Color is not the only quality of light that can be controlled through the use of filters. The character of light can also be changed by polarization, which has to do with the way light energy vibrates, and diffusion, which refers to the way light seems to spread over and around a subject, softening shadows and lowering contrast.

POLARIZING FILTERS

A polarizer is a neutral filter that can be used with both color and black-and-white films to eliminate or reduce reflections from grass, water, and even from blue sky. It is a very useful filter for photographing sunlit landscapes and seascapes and can be used for outdoor portraiture and fashion photography. It is frequently used to suppress unwanted reflections when copying works of art.

Normally, each beam of light vibrates in all directions around a central axis. It is easiest to understand if you forget your high school physics and think of light as being composed of an enormous number of particles, called photons, that spin around a central axis on the way to their destination, like multicolored cats running down a spiral staircase.

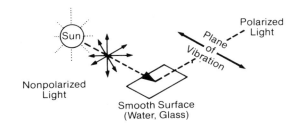

Nonpolarized light vibrates in all directions. When it glances off a smooth surface, such as glass or water, at a 30° angle, it becomes polarized and vibrates in one plane only.

When light glances off a smooth, nonmetallic surface at an angle of about 30°, its vibration is changed. Instead of vibrating in all directions, it vibrates in a flat plane. It's as though the spiral staircase were suddenly flattened out and turned into a standard flight of stairs that zigzags to its destination. Light that vibrates in one plane only is polarized.

The important thing about polarized light from the photographer's point of view is that it can be eliminated using a polarizing filter. Since the polarized light in a scene is almost always in the form of unwanted glare, hot spots, and reflections that reduce color saturation and destroy image quality, filtering it out is highly desirable.

The polarizing filter affects only polarized light, and then only when it is angled properly relative to the plane of vibration of the polarized light. Think of the polarizer as a microscopic grill. When turned at right angles to the plane of vibration, it stops the light from getting through. Turn it so that it lines up with the way the polarized light is vibrating and the light will slip right through. With light that vibrates in all directions, its effect is like that of a neutral density filter—it stops 60 to 70 percent of the light from getting through, which means you have to open up about 1½ f-stops to compensate. But it can stop polarized light cold.

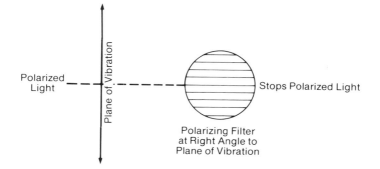

Polarized Light

Plane of Vibration

Stops Polarized Light

Polarizing Filter
at Right Angle to
Plane of Vibration

A polarizing filter set at a 90° angle to the plane of vibration of polarized light will stop the polarized light from getting through.

A typical polarizer comes in a rotating mount. The handle is supposed to facilitate rotation, although the types without handle and only a simple rotating ring are just as easy to use.

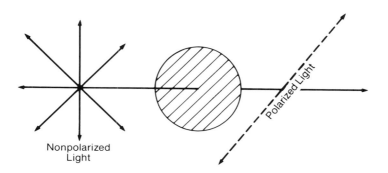

Nonpolarized Light

Polarized Light

Nonpolarized light passing through a polarizing filter becomes polarized in the same direction as the screen.

65

The most popular type of polarizer is in a rotating mount that lets you turn the polarizer while you look through it to see the position at which you get maximum glare reduction. Polarizing material is also available in square sheets and discs. You can use a polarizer most effectively when it is on an SLR, which allows you to look through the polarizer to observe the effect. On non-SLR cameras, you will have to look through the polarizer while it is off the camera, note the position at which maximum darkening occurs, and put it on the camera in that position.

Most good polarizers are coated to eliminate reflections and absorb UV radiation, so you do not need a UV or Skylight filter when you use a polarizer.

A polarizer is strongly recommended when you photograph landscapes in bright sunlight, because the light that glances from leaves, grass, dew drops, and other shiny surfaces will desaturate your colors unless it is filtered out. The effect is subtle, but it often marks the difference between adequate color and brilliant color.

The polarizer will also darken the polarized regions of a blue sky without darkening other colors in the scene. To

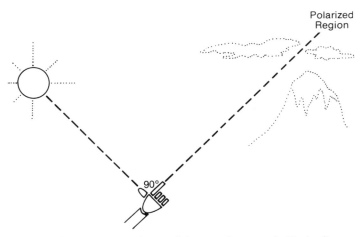

When the thumb is pointed toward the sun, the extended index finger points toward the polarized portion of the sky. This is the region that will be darkened most significantly through use of a polarizing filter.

find the polarized region of the sky, hold your hand so that your index finger points forward and your thumb points up at right angles. Now point your thumb at the sun. Your index finger will be pointing toward the arc of sky that is most highly polarized. This polarized region changes, depending on the time of day. It is high in the sky early in the morning and late in the afternoon. It is nearest the horizon around midday.

To eliminate reflections on the surface of water, which you may want to do in order to photograph fish swimming in a shallow pond or stones in a brook, hold the camera at about a 30° angle to the the surface and rotate the polarizer until the reflections disappear. Hold the camera at about a 30° angle to the glass to photograph through it while eliminating the reflections. The magic angles are in the region of 30° to 35°.

With most cameras, you can use a standard polarizer without trouble. However, cameras that incorporate a beam splitter in their metering system require a special circular polarizer. Many Super 8 cameras with reflex viewing and through-the-lens metering have a beam-splitter arrangement. There are also a few still cameras, such as the Canon Pellix, that require a circular polarizer. Using a standard polarizer with these cameras will produce faulty meter readings.

Most polarizers can be assigned a general filter factor of about 3× or 1½ f-stops, but for a more exact factor, consult the manufacturer's literature. There is some variation among polarizers. Since the polarizer customarily eliminates only unwanted glare, which does not contribute much to exposure, a general factor is usually adequate; however, you will get a more accurate reading by metering through the filter when it is adjusted to the position that will be used for taking the shot.

Occasionally, you will run across a polarizer that has been combined with a color-conversion filter to permit the use of tungsten-type film in daylight. This filter is used principally in motion-picture work, where the films are usually tungsten-type. It has a factor of about 6× or 1½ f-stops.

67

Reflections in this store window cause the main subject of the photo to disappear.

By using a polarizer at a 30° angle to the window, most of the reflections are eliminated and it can be seen that the model is actually wearing the clothing shown in the window. Both photos are by fashion photographer Kathleen Benveniste.

DIFFUSION AND IMAGE QUALITY

The degree to which light is diffused, or scattered across a scene, is a major element that determines the quality of an image. Outdoors, a typical example of extremely diffused light is the nearly shadowless light that you find on a heavily overcast day. The entire cloud cover seems to act as a giant, broad source of light. On a lightly overcast day, shadows will be soft, with indistinct edges, but quite visible. This type of

Even the most attractive woman will never look her best when photographed in harsh, directional light, because the light brings out every line in the skin.

A No. 3 diffusion filter eliminated the lines. Although diffusion produces some loss in apparent sharpness, the result is a far more attractive portrait than the undiffused version. Photos by Kathleen Benveniste.

lighting is good for portraiture and fashion work, provided that you correct the color by using cne of the 81 series of filters, such as the 81A (R1½).

Direct sunlight provides almost no diffusion. Shadows are hard-edged, and there is enormous contrast between the shadows and the sunlit portions of the scene.

Diffuse light gives a soft appearance to a subject. Wrinkles are smoothed out; surface blemishes seem to disappear. Most photographers prefer to work with diffused light.

In the studio, the degree of diffusion can be controlled using diffusers, umbrellas, scrims, and other diffusion devices in front of the light. Outdoors, the photographer has less control. This is where diffusion and low-contrast filters come into play.

A *diffusion filter* scatters the light from highlight areas into the shadow areas, softening the edges between highlight and shadow. This filter can be used to soften or eliminate wrinkles, depending on its strength. Diffusion

In direct light, shadows are hard-edged, and contrast between light and dark areas is considerable.

Diffusion filters scatter the light from highlight areas into the shadows, softening the edges between highlight and shadow. Diffusion filters are available in various strengths. Photos courtesy Tiffen Manufacturing Corp.

filters are available in various strengths. Some manufacturers offer a graded series; others simply offer one type.

A *low-contrast filter* scatters a uniform sheet of light across the surface of the image, which has the effect of lightening the shadows without noticeably affecting the lighter tones. Called "low cons" by professional cameramen, these filters are used extensively by Hollywood cameramen working on major motion pictures. Low cons are available in grades running from one through five. They make it possible

73

Straightforward photographs may be technically good but lacking in interest.

to balance contrast from shot to shot, even though the takes may be made on different days. They are not used much by still photographers, although they could be.

A *fog filter* seems to spread a white veil over the picture. Available in various strengths, the stronger the filter, the more noticeable the white veil and the softer the image. Some photographers will use fog filters in place of diffusion filters where a misty, romantic effect is desired, particularly in color shots.

Clear center-spot diffusers are now available from a number of manufacturers. These provide a clear image in the center surrounded by various diffuse or soft-focus surfaces. (Soft focus is discussed below.) Some have a gritty or bumpy surrounding that diffuses and scatters the light; others combine a diffuser with a smoky color to add a heavy white veil to the image surrounding the clear spot.

Do-it-yourself diffusers are easy to make. The simplest method is to breathe heavily on the lens and take

Fog filters are often used in place of diffusion filters to create misty, romantic images. Photos courtesy Tiffen Manufacturing Corp.

With backlighted subjects, use of a diffusion filter over the lens can emphasize the halo effect. Light is spread into the shadow areas, creating a luminous appearance.

your shot before the moisture evaporates. For more controlled effects, smear some vaseline on a clear filter or on an old Skylight filter. For a variable diffusion effect, try leaving the center clear and adding progressively more vaseline as you get toward the edges. This gives you an image that is clear in the center and almost completely misted over toward the edge of the frame. A little watercolor pigment, the kind that comes in tubes, added to the jelly will give you a practically infinite variety of color effects. But it's messy.

Nylon stockings also work as diffusers and will add their own color to the image if you are working in color. Any netlike material can be used as a diffuser. In fact, there are commercially available nets that are used for diffusion and even color control with professional motion-picture cameras.

It is easiest to focus before a diffusion attachment is placed over the lens; however, effects can only be judged with the attachment in place. A special problem with these devices is flare from lights and bright reflectors just outside the field of view of the lens. Watch out for it and change camera position if necessary to eliminate it. When a color filter is used in combination with a diffuser, low con, or fog filter, it should be placed in front of the diffusion attachment.

Underexposure reduces the effect of a diffusion filter; slight overexposure increases it. For strong diffusion effects with backlighted subjects, use contrasty film, such as Panatomic-X or Plus-X, or one of the faster color slide films. Low-contrast films with flat or diffusely lighted subjects tend to make the effect of the diffusion attachment disappear.

The aperture also has an effect on the degree of diffusion produced, with smaller apertures giving less diffusion. For maximum effect, use a large lens opening. If you have an SLR, preview the effect by stopping down to the taking aperture to be certain of the effect you will be getting.

SOFT-FOCUS ATTACHMENTS

Soft focus is actually a deliberate aberration introduced into the optical system. The soft-focus attachment has a surface with concentric grooves that allow part of the light to pass through unimpeded and part to be refocused slightly. The result is a double image—a principal image plus a slightly unsharp secondary image. The effect can be quite pleasing in portraits.

Before the days of computer-designed lenses, there were portrait lenses manufactured that gave this effect. Just for fun, you could try putting a close-up lens or a

magnifying glass on the end of a cardboard tube and using this in place of the lens on your SLR. Uncorrected lenses of this type can produce some remarkable images. You will have to play around with the tube, possibly making a telescoping system for yourself, in order to get the image focused.

5

Special Image Variations

This chapter deals with the use of special-effect attachments to get unique color effects, rainbow bursts of color, star effects, multiple planes of sharp focus, and multiple images. Since most of these attachments can be combined, the range of effects possible is mind boggling.

There is considerable difference of opinion among photographers regarding the use of special-effect attachments. It would seem, however, that those who are most vocal in their dislike of these devices are probably those who are least familiar with them. It takes some work to discover the subjects that work best with a special-effect attachment. In fact, if you look at the demonstration photos in the literature put out by the manufacturers of these devices, you will see that in many cases the photographers who took the photos for the brochure did not really know how to use these attachments. They are tricky. But when you get on to a group of subjects and situations that really work with one device or another, or with some combination of devices, you will be coming home time after time with batches of photos that are truly spectacular.

The use of black-and-white and color infrared films is also covered in this chapter, along with the filters required for effective use of these films.

COLORED FILTERS WITH COLOR FILM

The various colored filters used for tone correction and contrast control in black-and-white photography can be used effectively for photography with color films. Although not all scenes respond well to this treatment, those that do often result in exceptional images.

If you use medium- and dark-colored filters, the resulting scenes will be monochromatic—all red, yellow, green, and so on—in shades varying from light to dark. This effect seems to work best with subjects that are inherently contrasty and in which strong outlines predominate. For example, a dark-haired person photographed against a light background, such as the sky, appears in silhouette when photographed through a deep-red or yellow filter. If you try the same photo with a blond, the hair takes on the color of the filter and the shape of the head can be lost. Subjects that work well as silhouette are your best bet for use with deep-colored filters of any type, including those specifically designed for use with color film, such as the violet, purple, and other popular colors advertised in the photo magazines.

Lighter-colored filters, such as light-balancing and Color-Compensating filters, can be used to enhance a particular tone in a scene. For example, you could use a pale green filter to emphasize the coming of spring and the delicate greens of budding leaves. Red and yellowish filters add to a sunset quality. To simulate a sunset light, try an 81EF or an amber conversion filter with daylight film. To emphasize the bluish quality of a cold, rainy day, try an 82A, 82B, or 82C filter. For an even stronger effect, you could try a blue conversion filter (80A) or a Dark Blue (No. 47B) tricolor filter. By using Dark Blue filters, you can get particularly striking effects with backlighted subjects, such as clouds and mountains, photographed so that a burst of light from the sun just spreads out from behind the subject. You could combine the Dark Blue filter with a star-effect filter and multiple-image prisms (covered later in this chapter) for very complex effects.

TWO-COLOR FILTERS

The Two-Color filter is now available in a variety of configurations. These filters are half of one color, and half of another in combinations such as orange/green, yellow/purple, and red/blue.

Exposure compensation with Two-Color filters depends on the color combination and the density of the colors. For Orange/Green, try 2× or 1 f-stop; for Yellow/Purple, 3× or 1½ f-stops; for Red/Blue, 4× or 2 f-stops.

These filters are intended for use with color film, to produce exotic color effects. They have the advantage of providing greater variety than a single color filter but are more limited than graduated color filters used in combination.

VARIABLE-COLOR FILTERS

These special filters combine a polarizing element with a monochromatic or bicolored element to produce variable colors and variable color densities. Aside from a variety of offbeat color effects, such as those described earlier in the section on colored filters, these filters can be used with motion-picture and TV cameras to vary color during a scene.

There are two basic configurations for variable-color filters: The first type combines polarizer and color element into one filter; the second consists of a neutral gray polarizer and separate variable-color filters. The latter type allows you to use a single polarizer with a large number of variable-color filters produced by different manufacturers. The color element is attached to the lens first and the polarizer is screwed into the filter. By rotating the polarizer, you will either shift from one color to another or change the

color density, depending on the type of color element selected.

The variable-color filter makes possible a wide variety of effects, particularly when used in combination with other special-effect attachments, such as star filters and multiple-image prisms.

With the two-element type, you have the advantage of being able to use the polarizer as a basic polarizing filter (see Chapter 4) in addition to using it with the variable-color elements.

For shifts from one color to another, two single-color elements may be combined. Elements that provide a color shift are also available. These combined color elements allow you to change from red to blue, yellow to red, green to yellow, and so on.

Due to the combination of selective color absorption by the colored element plus polarization, it is impossible to assign an exact filter factor to variable-color filters. Through-the-lens exposure readings are the only practical method of determining correct exposure, and bracketing exposures is recommended.

Because these filters include a polarizer, they cannot be used with cameras that employ a beam splitter in the metering system. This can be a problem with some Super 8 cameras.

MULTIPLE EXPOSURE WITH COLORED FILTERS

Making several exposures through different colored filters, or combining exposures using the colors available in a variable-color filter, is a technique that adds significant variety to any photographer's repertoire.

To make nonoverlapping multiple exposures, place your subject against a dark background, make your first exposure, then shift the camera position so that the second subject, also against a dark background, is imaged in a previously dark (unexposed) area of the frame. Use a normal exposure, including filter factor, for each shot.

Multiple exposures with overlapping images can be simple to make if you are using a through-the-lens metering camera. For two exposures, find your normal exposure, with filter in place, then close down one stop. For four exposures on the same frame, close down two stops. This method provides only starting points, but the results will give you an idea of how various combinations might work. Keep records of what you do and eventually you will have combinations that are all yours.

Interesting results can be achieved by using color-separation filters. If you make a triple exposure, one through each of the primary color filters, and keep the camera motionless, moving parts of the scene, such as clouds or water, will appear in a rainbow of colors—red, blue, and green, yellow, cyan, and magenta. Still portions of the scene will appear normal.

The starting point for making the three shots is to take a normal exposure reading of the scene, then increase that exposure by one stop for each of your three exposures. For example, if you are shooting in sunlight on Kodachrome 64, and the normal exposure without filter is 1/250 sec. at $f/8$, then you would use 1/250 sec. at $f/5.6$ for each exposure. The filters to use are the Medium Red (No. 25), Dark Green (No. 58), and Dark Blue (No. 47B).

GRADUATED FILTERS

The typical graduated filter is half colored and half clear. The colored portion feathers out to colorless toward the center line of the filter. This feathering is known technically as graduated density.

Originally, graduated filters were used for sky darkening when making black-and-white motion pictures. For example, if a camera director wanted to get a dramatically dark sky for a cowboy movie chase scene, he might have selected a filter that was clear on the bottom and graduated into a deep-orange in the top half. Since almost all motion pictures shot today are in color, this use has

A split .9 ND filter was used to darken the sky and bring out its undulating texture in this view of Mohonk Lake, New York.

disappeared, with one exception, namely, the graduated neutral density filter, which is a half clear, half neutral gray light absorber that is used for contrast control.

The graduated neutral density filter is particularly useful for color landscapes when you want to darken a blue sky but need to get the lower part of the picture properly exposed. The filter is available in a variety of densities. For example, Tiffen offers it in densities of .3 (1 ƒ-stop), .6 (2 ƒ-stops), and .9 (3 ƒ-stops). The neutral density portion of the filter will darken half the image by 1, 2, or 3 ƒ-stops, which is more than enough for effective sky darkening. You can also use these filters to suppress a light source that comes within the field of view of the lens.

For example, this use brings out the texture of a lampshade and allows proper exposure of a person sitting beside the lamp. The trick in using the graduated neutral density filter is to position the demarcation area between the two halves in such a way that nothing which depends on

an even tone protrudes from one section to another. For example, trees or distant buildings could stick through the center portion, but not nearby people. Keeping a subject in the clear portion is easier outdoors if you use a camera position in which the subject is photographed from an upward angle. Graduated filters are easiest to use with SLR cameras, which allow you to see exactly where the dividing line falls.

Since the purpose in using sky-control (graduated neutral density) filters is to darken the sky by one to three stops, no filter compensation is required. Exposure readings should be made of the subject only—without the sky—and the camera adjusted accordingly.

Graduated color filters are used today primarily for special effects. They can be used singly, or in combination, for multiple color effects. When used singly, follow the manufacturer's exposure recommendation, if any, or run your own tests. No exposure compensation will emphasize the colored area with through-the-lens metered exposures. For correct exposure of the clear area, you may need to open up an additional ½ to 2 f-stops.

If you combine two of these filters, say a red and a purple to make a dual-color filter, you will need to compensate or use a through-the-lens meter reading. Exposure increases required for combinations usually run about 1 or 2 f-stops. Try factors of 2×, 3×, and 4× as starting points.

A graduated filter can be attached to the lens without worrying about the distance between the front element and the filter areas. A half focal length in front of the lens is the standard position for use with filters that have a sharp demarcation between clear and colored areas. Too close and the effect is lost; much farther and the line between colored and clear area becomes too sharply focused.

CLEAR-SPOT FILTERS

In addition to the clear-spot diffusers discussed in Chapter 4, there are a variety of filters that feature a clear central spot with a colored surrounding.

You can make your own version of the clear center spot by cutting out any shape you choose—circle, heart, star—in a piece of colored acetate. You can hold this in front of the lens, tape it on, or put it into a professional filter holder or compendium lens hood. The acetate adds aberrations to the colored portion of the image, which can be interesting, while the clear center portion still delivers the full quality of your lens.

Commercially made masks with cutouts in them are available for use with compendium lens hoods and professional filter holders. These masks are often not carried by dealers but are available through mail order. Check the ads in the photo magazines.

Commercial masks are available in opaque black, which gives a vignette the shape of the cutout, and in various translucent materials that provide diffusion and color effects.

Compendium lens hoods that accept these masks are usually of the bellows type, which allow you to adjust the distance between the lens and the accessory holder on the front of the hood. By adjusting the hood as you look through the lens of an SLR, you can vary the effect that you get with the various masks and change the definition along the edge of the cutout from slightly fuzzy to very soft.

STAR EFFECTS

Of all the special-effect attachments used today, the star-effect filter is far and away the most popular. Sometimes referred to as an "X" filter in magazine articles, it is used extensively by television and motion-picture cameramen to add sparkle to coverage of concerts, fashion shows, and entertainment spectaculars.

You can see star filters used regularly during televised performances of singers and popular music groups who frequently wear sequined and metallized fabrics that catch the light. The star filter takes these bursts of reflected light and turns them into four-, six-, or eight-point star bursts, depending on the filter used.

Industrial photographers also make frequent use of the star filter because it adds interest to otherwise commonplace shots of office and plant operations. The romanticized photos are subsequently used in literature promoting the company and its products to stockholders and potential employees.

A star filter has crosshatched lines inscribed in its surface. Where the lines intersect, point sources of light, such as bulbs, candles, and hot spots on the chrome trim of a car, will break up into a star pattern.

Star filters are available in various grid widths for each point pattern. For example, four-point star filters are commonly available in 2 mm, 3 mm, and 4 mm grids. The 2 mm grid provides diffusion and a slightly soft star effect. The 3 mm grid yields a brighter star and no diffusion. The 4 mm grid provides a brilliant star but works only with very strong point sources of light.

The small grids, such as the 2 mm, provide slightly soft effects plus sparkle, which is effective for portrait, fashion, and concert photography. The stars are not strong, but they glitter. Fashion photographers often use star filters in place of diffusion filters because they feel that the star filter gives their shots more life than they can get with straight diffusion filters.

Four-point stars are easy to capture on film. The six- and eight-point stars require stronger lights before the effect will work. Six- and eight-point stars are often chosen for television work where there are many brilliant lights. During the course of a show, the star effect will be noticeable only when a bright light or reflected highlight is in the field of view of the lens. This results in star flashes appearing at random intervals, which increases the visual novelty.

Best results with star filters are achieved when there is a strong source of light in the picture and the background is dark. Night street scenes work well if the camera is fairly close to the lights. If the lights are distant, the effect is weak or nonexistent.

Star filters can be used with any lens. Apertures from $f/4$ through $f/8$ are best. Smaller apertures tend to interfere

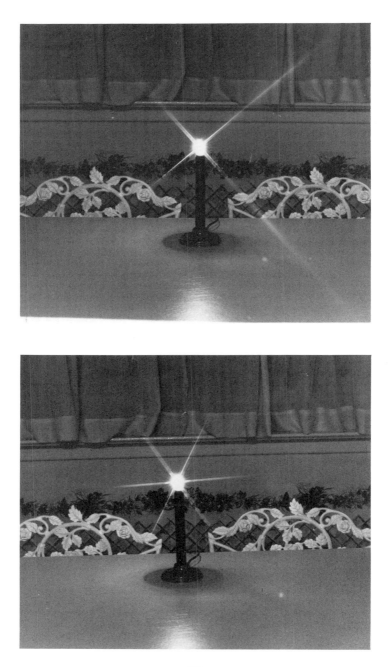

with the diffraction (star) effect while larger apertures diffuse it. When you use an SLR, preview the effect by stopping down to the taking aperture to be sure of the effect you are getting.

When star filters are used in combination with other filters, truly unusual effects can be achieved. For example, you might combine a six-point star filter with a variable-color filter.

A do-it-yourself star filter can be made from window-screen material. Put a swatch of window screen in

Star filters have crosshatched lines inscribed on their surfaces. Where the lines intersect, point sources of light will break up into star patterns. They come in various grid widths for each point pattern. Facing page: (Top) Four-point pattern with 2 mm grid; (bottom) six-point pattern with 4 mm grid. (Below) Eight-point pattern with 2 mm grid. Photos courtesy Tiffen Manufacturing Corp.

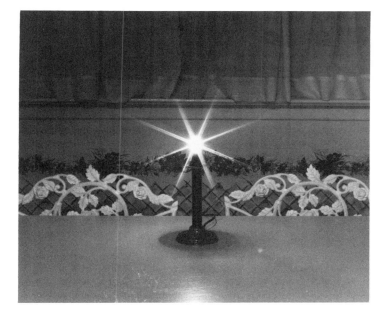

(Facing page) The pattern of lights in an underground parking garage becomes a space fantasy when photographed through a four-point star filter.

90

(Facing page) An eight-point star filter was used to capture some of the excitement of the circus in this unusual wide-angle shot. The dark areas around the edges of the frame enhance the effect but were the unplanned result of vignetting produced by the filter mount, which protruded into the field of view covered by the lens. Photo © Robert A. Smith, 1978.

a professional filter holder, or just hold it up in front of the lens. The effect will depend on the mesh of the screen and its distance from the lens. For an additional offbeat effect, try sprinkling a few drops of water on the screen. Window-screen material will also act as a diffuser and will add its own color to the scene. For neutral color effects, use a gray screen.

City lights at night seem to vibrate with excitement when photographed through a star filter.

Star filters give best results when there is a strong source of light in the picture, the background is dark, and a considerable distance exists between camera and light source, as in this series (see also pages 94 and 95) photographed with a black paper background and a 135 mm lens. Shown here is a four-point star filter (3 mm grid).

Six-point star filter (3 mm grid).

Eight-point star filter (3 mm grid).

DIFFRACTION AND PRISMATIC EFFECTS

A dramatic technical breakthrough occurred when filters became available that incorporated hundreds of holographic prisms in the surface. These filters break up point sources of light into multipointed bursts of rainbow colors. An appropriate name for them is spectral-burst filters; however, each manufacturer has its own brand name.

Unlike the diffraction gratings, which until a few years ago provided the only means of getting the rainbow effect, these new filters will provide dramatic breakup of fairly weak light sources, and the color effects are very strong.

The classic diffraction grating consists of a microscopically fine grill of lines on the surface of the filter. These lines break up strong sources of light into a rainbow-colored secondary image.

The colored secondary image provided by a diffraction grating is displaced from the primary image. The distance of the displacement depends on the camera-to-subject distance. In working with diffraction gratings, experienced photographers tend to use moderate telephoto lenses and find backlighted subjects, such as a cathedral with the sun peeking out from behind. The result is a burst of color in the dark portion of the picture.

Holographic prism-type filters are much easier to use and often less expensive than diffraction gratings. The color effect is strong, regardless of the background, and in most cases the light sources in the scene are completely surrounded by halos of red, green, blue, yellow, magenta, and cyan streaks. The actual pattern varies, depending on the filter. When you go into a store to look at one of these spectral-burst filters, hold it up to any bright, point light source to see the effect you will get.

The spectral-burst filter adds some diffusion to a scene and may give a smear of multiple-colors across broad highlight areas. It can be combined with variable-color filters and multiple-image prisms (discussed below) for spectacular results, particularly with backlighted subjects.

MULTIPLE-IMAGE PRISMS

The multiple-image prism takes a single image and repeats it in various configurations. Like the star and spectral-burst filters, the multiple-image prism does not add to exposure, so you can use it anywhere. More importantly, you can combine multiple-image prisms for extreme image breakup without affecting exposure.

The two basic configurations for multiple-image attachments are: radial and linear. The radial pattern may consist of several triangular prisms radiating out from a central point, or it may have a clear central area surrounded by five or six prisms that will repeat the central image. The accompanying diagrams and demonstration photos make the effect clear.

The linear-type prism breaks the image up into lines, running the full length of the image, which repeat the

Three-facet multiple-image prism.

Six-facet multiple-image prism.

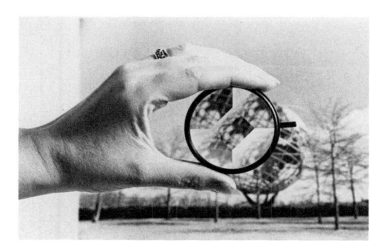

Five-facet multiple-image prism with flat center facet.

98

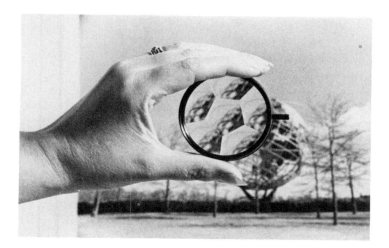

Six-facet multiple-image prism with flat center facet.

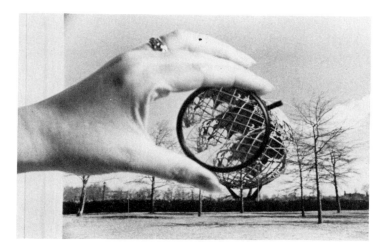

Multiple-image prism with three parallel facets.

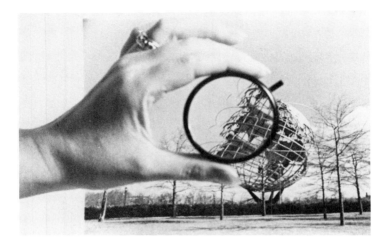

Multiple-image prism with five parallel facets.

Multiple-image prism — half clear, half with six parallel facets.

100

neighboring image segment. To get a better idea of what these prisms do, look at the accompanying demonstration photos and diagrams.

The strongest effect with radial-type prisms is achieved by imaging a light subject against a dark background. However, these attachments are also effective with light backgrounds, particularly if the subject is one that works well in silhouette, such as a bridge or piece of outdoor sculpture.

Combining multiple-image prisms yields an enormous range of effects. For example, combining a six-line linear type with a three-prism linear type or five linear at right angles creates a checkering effect. Or you could try a triangular pattern plus a three linear. And so on.

Try combining multiple-image prisms with a colored or variable-color filter and perhaps a spectral-burst filter to photograph a silhouette subject with a strong light, such as the sun, in the scene. Use a through-the-lens metered exposure for optimum color saturation, then try opening up a half stop for a different color effect. The results will almost certainly be worth the effort.

FILTERING THE LIGHT SOURCE

Although this book is about on-camera filtration, the spectacular effects that can be achieved by filtering the light source should not be neglected. For example, in color studio photography, you can project colored images onto your subject using any standard slide projector, or you can put colored filters on the lens of a projector and use it as a colored spotlight.

Many electronic flash manufacturers now offer kits of colored filters to use over the flash head for special lighting effects. You can also make your own by using any piece of colored acetate over the flash. Acetate is available in a rainbow of colors and densities from art supply stores. Any type of colored plastic can be used as a filter for lights as long as it is not opaque.

Acetate may also be used in front of studiofloods and photofloods; however, be careful not to melt the acetate.

(Left) The three-facet prism produces a triangular pattern. The most stable composition is created when the base of the triangle is at the bottom of the photo and the apex at the top, as illustrated here. (Below) A six-facet multiple-image prism produces six clear images in a circle when the subject is photographed against a dark background.

The six-facet multiple-image prism with a flat center facet produces a ▶
central image in the middle of five repeating images that encircle the
subject.

◀ The five-facet multiple-image prism with a clear center facet produces a central image ringed by four repeat images. The effect can be that of a square (as here) or diamond, depending on how the prism is rotated.

The clear half of a six-parallel-facet prism can be positioned so that the space behind a moving subject is broken up by prisms, emphasizing the forward motion. This prism is sometimes called a six-linear or six-line prism.

If the prismatic portion of the six-line attachment is placed in the lower half of the frame, the subject seems to lift upward.

A prism with three parallel facets can be used to develop unusual
compositions with static subjects, depending on the position of the
facets.

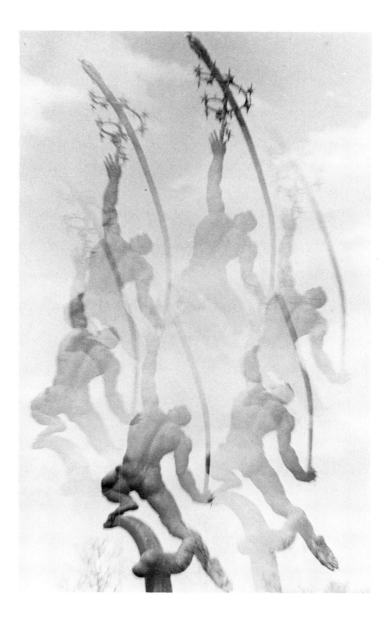

A six-facet multiple-image prism used in combination with a Dark Yellow (No. 15) filter for moderate sky darkening helped echo the upward thrust of this sculpture.

Special filters, called "gels," are available for use with hot lights. These are sold by theatrical supply companies.

Using different filters for each of several light sources produces multicolored effects. You can combine colored lighting with on-camera star filters, spectral-burst filters, and multiple-image prisms for additional effects without significantly affecting exposure.

SPLIT-FIELD AND CLOSE-FOCUS-SPOT LENSES

Normally, the only way a photographer can get both very near and distant subjects in focus at the same time is to use a small aperture and an extremely wide-angle lens. The result is a photo in which close objects are large, distant objects small, and size is determined by the lens and camera-to-subject distance. This is typical wide-angle perspective and it is limited.

To get normal and telephoto perspectives plus the appearance of extreme depth of field, you need a split-field or close-focus-spot attachment.

The split-field lens is part close-up lens and part clear. The combination produces two fields of focus, one near and the other far, which you can use to create extreme depth-of-field effects or to combine small items, such as a seashell, with normal-appearing subjects in the middle distance or background.

The close-focus-spot lens has a close-up lens in the center of a clear field. This attachment lets you put a tiny subject in the middle of a larger, more distant subject and control the relative sizes of both. In other words, you could make a bug on a thread look as though it was eighty feet high and crawling up the side of the World Trade Center building.

To focus and compose using a split-field or close-focus-spot attachment with an SLR, first focus on the middle-distance or background subject through the clear part of the attachment by turning the focusing mount on the lens. Next bring the close-up subject into sharp focus by looking through the close-up lens part of the attachment and moving the entire camera or lens toward or away from the

(Top) a 135 mm lens used for portraits on a 35 mm camera provides pleasing perspective for head-and-shoulders portraits, but depth of field is shallow and either foreground or distant background cannot be imaged sharply, even when small f/stops are used. (Bottom) By using a split ½-diopter filter, both the subject in the foreground and the distant background may be clearly imaged.

111

Focusing with a split-field lens is achieved by first focusing on the middle distance or background through the clear part of the lens, and then bringing the close-up subject into focus through the close-up part of the attachment. Photo courtesy Tiffen Manufacturing Corp.

subject until you find the point of greatest sharpness. The close-up subject will always appear sharpest at a fixed distance from the lens, depending on the strength of the close-up part of the attachment.

Close-up strength is usually indicated in diopters, which are a measure of optical power. With a lens focused at infinity, a +1 diopter lens will be in focus at 98.37 cm (38.75″) from the front of the attachment; a +2 lens at 49.55 cm (19.5″); a +3 lens at 33 cm (13″). These distances remain constant, regardless of the focal length of the lens on the camera.

By selecting one focal-length lens over another, you can control the size of the middle-distance and background subjects. By selecting the strength of your close-up split or spot lens, you control the size of the close-up subject.

To avoid imaging the split when working with a split-field lens, try angling the attachment so that the line falls in some naturally soft portion of the picture, such as a hairline, water, sand, or the green felt of a pool table.

Split-field and close-focus-spot attachments are easiest to use with cameras that provide through-the-lens viewing. To use these lenses with other types of camera, you have to measure the distance between close-up attachment and subject and estimate the location of the split in the final picture.

For best results, use an aperture of $f/11$ or smaller with any type of close-up attachment. The small apertures help minimize aberrations in the attachment lens and give you extra depth of field, which is usually a plus with close-up subjects.

BLACK-AND-WHITE INFRARED

Using infrared film allows you to penetrate the unseen world of infrared radiation. Infrared is a long wavelength of electromagnetic radiation just below the red end of the visible spectrum. It penetrates atmospheric haze like a hot knife through margarine and is reflected strongly by healthy, leafy plants. These facts suggest two of its principal

In a landscape taken on standard panchromatic film, such as Kodak Plus-X, grass and leaves have a medium tonal value.

uses: aerial photography and scientific investigation. It is also used in surveillance work, museum photography, and forensic (legal investigative) applications.

Black-and-white infrared film is sensitive to blue, red, and infrared light. It should be used in conjunction with a Dark Yellow (No. 15) or Orange (No. 16), Medium Red (No. 25), Dark Red (No. 29) or black Infrared filter (Nos. 87, 87C, 88A, and 89B). The Dark Yellow, Orange, and Red filters eliminate blue. The black, visually opaque Infrared filters eliminate blue and visible red light, resulting in a photo made entirely from invisible radiation.

For general outdoor photography, the Dark Yellow (No. 15) or Orange (No. 16), Medium Red (No. 25), or Dark Red (No. 29) is usually satisfactory. This combination of film

114

and filter produces nearly black skies in the finished print; healthy green foliage appears almost white because its cell tissue reflects a significant amount of infrared; coniferous trees, such as spruce and pine, appear dark.

Infrared film is frequently used in aerial photography because of its haze-penetrating ability. In this application, Medium Red (No. 25) or Infrared (No. 89B) are recommended filters. The same film/filter combination can be used effectively when photographing distant terrestrial objects through very long telephoto lenses and telescopes.

Exposure varies, depending on the filter used and the infrared intensity of the light source; however, a starting point for use with Kodak High Speed Infrared Film and a Dark Red (No. 29) filter is ASA 60 (DIN 19). (This ASA

When a scene is photographed on infrared film, grass and leaves are almost white because the living cells reflect large amounts of infrared light. Tone values in the building changed only slightly; however, the roof is considerably darker—an effect that could not be predicted beforehand.

speed takes into account the filter factor for the Dark Red filter and is intended for use with handheld meters.) Bracket exposures to be certain of getting the effect you want. Light meters do not measure infrared and so can only provide a rough guide to exposure.

Light sources for studio and laboratory work vary. Electronic flash is preferred by many workers because it is easy to handle and does not burn up delicate specimens the way hot tungsten and quartz lights can. Infrared heat lamps do not make good light sources because they emit a long wavelength, close to heat, which cannot be recorded by infrared film.

Infrared rays do not come to a focus at the same point as visible light rays, so unless you have an infrared-corrected lens, which is a scientific instrument, you will need to adjust your focus. This is easy to do if your lens has a small "R" on the distance scale. Just focus normally, note the distance indicated by the index mark on the focusing scale, then adjust the focus so that the noted distance is opposite the "R." If you do not have an infrared focusing mark on your lens, focus on the near side of your region of primary interest and stop down for maximum depth of field.

PHOTOGRAPHING IN THE DARK

To photograph in the dark, use an Infrared (No. 87) filter over your light source. You can get one of these as a gelatin filter or as a gelatin filter mounted in glass. Put the filter over your electronic flash, eliminate any light leaks with black masking tape, and blast away. Unless someone looks directly at the flash as it goes off, it will not be seen. If you look directly at the filtered light, you can see a red glow.

Extremely sophisticated infrared surveillance and photography systems are available that are advertised in trade magazines for law-enforcement personnel. These outfits will do a lot more than the simple candid photography arrangement just described, but they are expensive.

Using infrared allows you to unobtrusively photograph people and animals in the dark. It is a sneaky but

effective way to get candid portraits. Just remember that if you "publish" a photo of someone taken without their knowledge and permission, you could be in trouble for violating their right to privacy. *Publish* is a broad term. Just showing photos to some friends, or hanging your pictures on a gallery wall, could be construed as publication, particularly if the photos in any way demean the subject or hold a person up to ridicule.

COLOR INFRARED

Color infrared transparency film was originally developed for use in camouflage detection, a short-lived use since most camouflage materials are now treated to reflect infrared. Today, films such as Kodak Ektachrome Infrared are used extensively in aerial survey work to determine facts about the nature of forests, planted fields, pollution, and so on.

This is a false-color film, which means that the colors in the original scene are falsified by dyes in the emulsion, so that infrared reflectivity, or lack of it, is clearly visible. A typical color rendition with infrared film and a Dark Yellow (No. 12) filter, which is recommended for all careful work, contains blue skies and red foliage. Healthy leaves are red. Dead, diseased, and dying leaves are greenish or bluish. Foliage that may be in trouble will come out yellow. Conifers such as pines are dark purple. Blue and red flowers tend toward yellow. Green paint comes out blue.

For all scientific and technical applications, the recommended filter is the Dark Yellow (No. 12). For general pictorial work, you could use a Medium Yellow (No. 8), Dark Yellow (No. 15), or Orange (No. 16). When you decide that you have taken enough pictures with blue sky and red grass, try a Medium Red (No. 25) filter, which turns blue skies green, grass orange, and clouds yellow.

The starting point for hand-metered exposures using Kodak Ektachrome Infrared Film with a Dark Yellow (No. 12) filter on the lens is ASA 100 (DIN 21). The color effects are strengthened by underexposure and you may find that on a sunny day and using through-the-lens

metering, a good general setting is ASA 125 (DIN 22). For best results, bracket your exposures.

This is a daylight-type film, so for indoor work your best light source is electronic flash.

6

Directory of Situations and Techniques

This is basically a reference chapter, organized alphabetically to make it easy to look up specific situations and techniques without hunting through several chapters for passing references. The entries are not exhaustive. But they do give a general guide for the use of filters in a variety of photographic situations from aerial photography to copying to zoom effects.

AERIAL PHOTOGRAPHY

When photographing from airplanes, including commercial airliners, light planes, and helicopters, use some filtration—a Skylight or UV or Haze filter at the very least—and a high shutter speed, the faster the better. On hazy days, try an Orange (No. 16) or Dark Yellow (No. 15) filter with black-and-white film. A Medium-Red (No. 25) is adequate for black-and-white infrared film.

For color work, the pale-yellow Haze and UV filters work well, as do light-balancing filters, which can also be used for haze penetration. With color infrared film, use a Dark Yellow (No. 12) filter.

Black-and-white shots of buildings often lack punch when skies are blue and no filter is used on the camera.

A Medium Red (No. 25) filter darkens the blue skies, which brings out the white clouds and produces a dramatic setting for the building.

Light-colored sculpture, such as this silvery missile, stands out best when photographed against a darkened sky. A Medium Red (No. 25) filter produced this effect.

ARCHITECTURE

For black-and-white photos of buildings, bridges, and other large subjects, use a Medium Yellow (No. 8) correction filter for accurate results. For more dramatic effects, darken blue skies and bring out cloud patterns using orange or red filters.

You do not need a filter when photographing architectural details, such as a cornice; however, with colored subjects, using a filter the same color as the subject and underexposing by about ½ ƒ-stop can help bring out subtle details. For example, a yellow filter helps bring out the grain pattern in oak furniture.

For color work, use a Skylight filter or a polarizer. To eliminate the yellow cast that early morning or late afternoon sun gives to white and gray surfaces, try an 82 series filter, such as the pale-blue 82A. On a cloudy day, you can get a warmer overall tone by using an 81A filter.

ART

When making black-and-white records of artwork with daylight or electronic flash, use a Medium Yellow (No. 8) correction filter. In tungsten light, use a Yellow-Green (No. 11) correction filter.

Works of art can be tricky to photograph. Correction filters are fine, but avoid contrast filters, which distort tonal values. Watercolors are particularly hard to photograph because natural contrast is very low. To get good tonal separation, use a contrasty film, such as Kodak Panatomic-X, and a Yellow-Green (No. 11) correction filter on high-contrast panchromatic copy film developed for continuous tone. Photo © Julie Lomoe, 1976.

To eliminate glare from painted surfaces, use a polarizing filter over the lens and polarizing material in front of your light sources. This procedure improves color saturation and detail rendition.

For color photographs of artwork, use standard daylight or electronic flash. Try to avoid situations where you have to guess about corrective filtration. With tungsten lighting (studiofloods or 3200 K quartz lights), use tungsten-type film or daylight film with a blue 3200 K to 5500 K 80A conversion filter.

BEACHES

Always use a filter at the beach, if for no better reason than to protect your lens from the effects of blowing sand and salt spray. A Skylight filter is adequate for general work in black-and-white or color; however, many experienced photographers recommend using a polarizer for color photography because it darkens blue skies and improves overall color saturation.

To obtain dramatic black-and-white seascapes, try a Dark Yellow (No. 15) or Orange (No. 16) filter.

BLUE COLOR CAST

An unwanted blue color cast can have a number of causes, some of which can be corrected by filtration. For example, if you use indoor color film in daylight without an amber conversion filter, you will get a strong overall blue cast. This occasionally happens to Super 8 photographers who forget to unscrew the plug from the movie-light socket or who leave the camera filter button depressed.

A cloudy day or open shade will give a blue color cast to most films. Try using an 81A or R1½ as a starting point for corrective filtration. A Skylight filter will provide partial correction. Use the same filter combinations for snow scenes.

Some electronic flash units produce excess amounts of blue light. Any light-balancing filter will help; however an 81EF or R6 is recommended as a starting point.

Some fluorescent lights produce a bluish or blue-green cast. See Fluorescent Lighting.

Fully corrected indoor photos may appear too cool, because people sense tungsten light as being warm, even though they perceive it as white. For a natural appearance with household light bulbs, try an 80A filter to correct daylight to studioflood light plus an 81A, which gives only partial correction. With studioflood lighting, try an 80B correction filter with daylight film for a warmer feeling.

Worn-out or improperly balanced processing chemistry can also turn film blue. There is little you can do about this other than changing photofinishers.

CLOUDS

See Sky Darkening.

COLOR PRINT FILM

Most photographers do not bother to filter today's color print films because automatic printing machines used by photofinishers correct for most common lighting situations. However, if you do your own color printing, or have it done by a custom lab, you may want to use conversion filters when photographing in tungsten light (household bulbs, studiofloods and photofloods, and quartz lights).

It never hurts to use a Skylight filter.

Mass photofinishing is a blessing in that you seldom get really bad prints and the cost is low; on the other hand, you seldom get really good prints either. Off-color and blurred prints are as often the printers fault as they are due to poor photographic technique. Sometimes it is hard to tell just where the problem lies, which makes evaluation difficult.

COLOR SEPARATION

The purpose of color separation is to get three black-and-white negatives that provide a three-color record of a full-color subject. These negatives can be printed in register through tri-color filters onto color print paper to make full-color prints.

With the advent of good internegative materials and processes such as Cibachrome, which allow the photographer to make color prints from transparencies, most photographers do not bother with separation negatives. The technique is almost exclusively the property of printers, like the ones who printed the color section of this book.

On the other hand, some museums have begun requesting color-separation negatives from photographers as a means of preserving color photos that are considered art. Prints fade. Black-and-white separation negatives can last for hundreds of years.

To make separation negatives from original subject matter, make separate exposures on separate pieces of film using the Medium Red (No. 25), Dark Green (No. 58), and Dark Blue (No. 47B) filters. If you base your exposure time on the red filter, then the green gets about twice the exposure and the blue about four times the exposure; however, these exposure ratios vary. For more accurate recommendations, check the instructions that come with the separation film.

To make separation negatives from transparencies and color prints, use the Dark Red (No. 29), Dark Green (No. 58), and Dark Blue (No. 47B) filters.

COMBINING FILTERS

To find the filter factor for filters used in combination, multiply filter factors or add the exposure increase in f-stops for each filter. For example, if you combine a polarizing filter, which has a factor of about 3× or 1½ f-stops with a Medium Red (No. 25) filter, which has a factor of 8× or 3 f-stops, the combined factor would be 24× or 4½ f-stops.

To combine a polarizer with some other filter, put the

polarizer closest to the lens. If you use a close-up lens or split-field attachment, the close-up lens goes closest to the lens, followed by the polarizer (if any) and colored filters (if any).

When using multiple-image prisms, the prism goes closest to the lens, followed by close-up lens, then polarizer or variable-color filter element, diffuser, colored filter, and spectral-burst or star filter.

COPYING

It is easy to overdo the use of filters in copying. In most cases, filters are unnecessary for black-and-white work.

To make color copies and slide duplicates, you should balance the light for the film. Some light sources, such as electronic flash, may require little or no filtration with daylight slide films; other sources, such as tungsten illumination, should be corrected in the same way as for normal photography.

Makers of slide duplicating equipment that includes a light source usually provide filtration recommendations for a variety of film stocks. If you follow those suggestions, it is almost impossible to go wrong.

Selective use of light-balancing and Color-Compensating filters lets you make color corrections in slide duplicates. Use of special-effect and colored filters in slide duplicating produces unusually colored and distorted images. The potential variety is endless.

Occasionally, you will run into special copying problems, particularly when copying archival material. To eliminate stains, choose a filter the same color as the stain. For example, you can usually eliminate coffee and tea stains by photographing through a Dark Yellow (No. 15) filter. To eliminate blue graph lines, photograph through a Dark Blue filter.

To improve the legibility of faded brown ink, try a Dark Blue filter. To increase contrast when copying blueprints, use a Medium Red filter.

Some subjects are inherently low in contrast. For example, watercolors tend to wash out almost completely

In copying prints, stains may be eliminated by copying the photo onto panchromatic film through a lens the same color as the stain. The coffee stain visible in the photo above was completely eliminated by use of a Dark Red (No. 29) filter (below).

when photographed on a general-purpose film such as Plus-X. Filtration does not help. (But you could try using a panchromatic copy film, such as Kodak High Contrast Copy Film, and developing it in a continuous-tone developer such as D-76. The procedure is not recommended by Kodak, but it can work.)

To lower contrast when making slide duplicates, try flashing the film. You can do this by photographing a piece of matte white paper, using the same exposure time and f-stop that you have established for your copy shot, with a combination of ND 1.5 and ND 0.1 neutral density filters over the lens.

FILTER EQUIVALENTS

See accompanying table to find the brand names of roughly equivalent filters produced by different manufacturers. These are rough estimates only. Transmission characteristics do vary from brand to brand, even with filters that have the same name or number.

FLASH PHOTOGRAPHY

Good electronic flash units have coated reflectors or built-in UV filters that provide correctly balanced light for daylight color films. Flash units that throw out an excessive amount of blue can usually be corrected by using an 81EF or UV17. If that is too strong, try one of the lighter light-balancing filters, such as an 81A. Or try your Skylight filter for partial correction.

Blue flashbulbs require no filtration. Clear flashbulbs are seldom used today in the United States but are still found elsewhere. To correct zirconium foil-filled flashbulbs for use with daylight film, use an 80D (factor: 1.5× or ⅔ f-stop). To correct aluminum foil-filled flashbulbs for daylight film, use an 80C (factor: 2× or 1 f-stop).

FILTER COMPARISON CHART*

Filter Color and Wratten No.	Aetna Rokunar	B + W	Hoya	Rolen	Tiffen	Vivitar	Discontinued Kodak Designations	f-Stop Increase (Approx. Daylight)
Light Yellow (6)		Light Yellow (021)		6 (Yellow 1)	6 (Yellow 1)		K1	2/3
Medium Yellow (8) Yellow (Y2)		Medium Yellow (022)	K2	8 Yellow	8 (Yellow 2)	K2	K2	1
Dark Yellow (9)		Dark Yellow (023)		9 (Yellow 3)		K3	1	
Yellow-Green (11)	G53	Yellow-Green (060)	X1	11 Green	11 (Green 1)	X1	X1	2
Yellow-Green (13)				13 (Green 2)		X2	2 1/3	
Dark Yellow (12)				12 (Yellow)			1	
Dark Yellow (15)	056		G	15 Orange	15 (Deep Yellow)	G15	G	1 1/2
Orange (16)		Yellow Orange (040)		16	16 (Orange)	O2		1 2/3
Dark Orange (21)		Red Orange (041)		21	21 (Orange)			2
Light Red (23A)		Light Red (090)		23A	23A (Light Red)			2 1/2
Medium Red (25)	R60	Dark Red (091)	25A	25 Red	25A (Red)	25(A)	A	3
Dark Red (29)		Deep Dark Red (092)		29	29 (Dark Red)		F	4 1/3

*These are only rough equivalents. There will be variations from brand to brand, but these can be ignored for most general picture-taking situations.

130

FLUORESCENT LIGHTS

Use an FLD filter with daylight-type color film if you are getting a blue or blue-green cast. Alternatively, try a CC30R, 81EF, or R6. For precise correction, follow the recommended CC filter combinations given in Chapter 2, or use a Tri-Color Meter. For correction with tungsten-type film, use an FLB filter.

Commercial photographers should test before committing themselves to a particular filter combination. If there is no time to test, they should bracket filtration.

In some cases, no correction produces better results than an FLD or FLB filter. In other situations, the fluorescent-light filter is definitely preferable.

No filtration is required with black-and-white film.

LANDSCAPES

For general landscape photography in black-and-white, use a Medium Yellow (No. 8) correction filter. To get darker blue skies, try a Dark Yellow (No. 15) or Orange (No. 16) contrast filter. A Medium Red (No. 25) filter produces strong sky darkening but falsifies tonal values in foliage.

When photographing in the woods or in foliage-filled areas, try using the Yellow-Green (Nos. 11 and 13) correction filters to bring out subtle differences in shades of green.

In desert areas, subtle greens and tans can be separated out by using Light Green (No. 56), Dark Green (No. 58), Light Red (No. 23A), and Medium Red (No. 25) contrast filters.

A Dark Blue (No. 47B) filter can be used at twilight in dry areas to lighten rocks and darken foliage. It lightens rocks because they reflect a significant amount of skylight.

In humid climates, a Dark Blue (No. 47B) filter emphasizes the impression of haze and mist.

To cut through haze in black-and-white work, use any of the correction or contrast filters. An orange filter provides a haze-penetrating effect with most films that is similar to that achieved by the human eye.

A polarizing filter is probably the most useful all-around filter for color landscape photography. Color correction is not usually a problem because most photographers like the varied color qualities that they get using uncorrected light. The polarizer improves color saturation in some cases but does not alter color quality.

LIGHT BULBS

Standard household light bulbs contain a tungsten filament that provides a good source of illumination for photography. In a pinch, new 100-watt bulbs can be used for reasonably precise work with daylight films by combining an 80A conversion filter with an 82B (B3) light-balancing filter. With older 100- and 75-watt bulbs, you may have to use an 82C (B6) in place of the 82B to achieve full correction (combined factor: 5× or 2 ⅓ ƒ-stops).

A natural-appearing indoor scene is not produced by full correction, which cancels the warm quality of tungsten light. To retain warmth in the scene, try partial correction. You might try an 80A alone with daylight-type film, or an 80A plus an 82 or 82A. This would provide a combined filter factor of 5× or 2⅓ ƒ-stops.

Use a similar correction for 75-watt bulbs. For 40-watt bulbs, additional correction is required.

MIXED LIGHTING

When confronted with mixed lighting situations in color photography, there is no one filter that will meet all your needs. For example, if your scene is lighted by a combination of fluorescent tubes and daylight coming through windows, perfect color will be unobtainable. One solution would be to turn off the fluorescents and work by daylight; but if your object is to record an office environment, you may prefer to filter for the fluorescents and let the daylight take care of itself.

As a rule, correct for the light that is on the main subject. If the subject is lit by more than one type of light

132

and you cannot get rid of one, then correct for the light that dominates. Or correct so that a cool or warm feeling predominates, depending on how you feel about the scene.

NUDES

In black-and-white work, no correction is necessary; however, you may want to use a Yellow-Green (No. 11) correction filter if your object is optimum rendition of flesh tones.

In color photographs, use conversion and light-balancing filters as required if you want to obtain natural-looking color. Use any of the special-effect techniques to add variety to your shooting sessions.

PORTRAITS

In black-and-white portraiture, use a Yellow-Green (No. 11) correction filter for optimum flesh tones. To give a man's portrait a more rugged quality, try the darker Yellow-Green (No. 13).

In color portraiture, use daylight or electronic flash, or both. No color correction is necessary if you use color print film. If you combine electronic flash with open shade, use the flash as your key light and filtration should not be necessary. Under cloudy skies with no auxiliary lighting, try an 81A light-balancing filter as a starting point.

RED CASTS

Household light bulbs, studiofloods, photofloods, and quartz lights all produce a reddish cast with daylight-type films unless a conversion filter is used. To convert photofloods (3400 K) to daylight quality, use an 80B. To convert studiofloods (3200 K) to daylight quality, use an 80A (see also Light Bulbs).

Reciprocity failure can produce a reddish-brown cast with some films. Follow the film manufacturer's filter and

exposure recommendations for long exposures. For example, with Kodachrome 25 and a ten second exposure, Kodak recommends using a CC10M filter and 1½ f-stops additional exposure.

SKY DARKENING

The principal filters used for sky darkening in black-and-white photography are the yellow, orange, and red series. For normal tone rendition, use a Medium Yellow (No. 8) correction filter. For greater darkening of blue skies, try a Dark Yellow (No. 15) or Orange (No. 16). For even darker skies, use the Medium Red (No. 25) or Dark Red (No. 29).

The sky-darkening effect of a filter depends in great part on atmospheric conditions, with strongest results achieved under the brilliant blue skies typical of desert and mountain regions. The photo below was taken with no filter. The photo at top right, taken with a Deep Yellow (No. 15) filter, shows some darkening, but not as much as in the photo at bottom right, where a Red 1 (No. 25A) filter greatly increased the contrast between sky and clouds.

135

The effect of contrast filters on the sky will depend on the color quality of the sky itself. The greatest effect will be achieved with clear blue skies high in the mountains. The smoky-blue skies in polluted city areas do not show much darkening because they are a pale blue, which is only susceptible to moderate darkening.

Contrast filters will have absolutely no effect on overcast skies.

A graduated neutral density filter (see also Chapter 5, under Graduated Filters) can be used with either color or black-and-white to darken any sky area, including overcast skies. This filter provides the only means, other than polarization, to darken skies in color photography.

A polarizing filter will darken the arc of blue sky that is at right angles to the sun. If your camera angle and subject position are correct and you get effective sky darkening, count yourself lucky.

SNOW SCENES

On a clear day, snow acts as a reflector for UV and blue skylight. In black-and-white photos, the result is unnaturally light shadows unless a Medium Yellow (No. 8) correction filter is used. In color photography, the reflected blue light turns flesh tones cyanotic. You can partially correct by using a Skylight filter. An 81A provides additional correction but may make the snow appear too warm.

TELEPHOTO PHOTOGRAPHY

In black-and-white work through very long telephoto lenses, a Medium-Yellow (No. 8) or Orange (No. 16) can be used to cut through haze. Try the Light Yellow (No. 6) for haze cutting without using a filter factor. The Light Yellow is ideal when you photograph sports action from the top seats in an arena using Big Bertha-type tele lenses.

In color work, try a Skylight or Haze filter for slight haze penetration. If you do not mind a yellowish cast to your

pictures, use one of the stronger UV filters or a light-balancing filter.

UNDERWATER PHOTOGRAPHY

The quality of light under water changes rapidly, depending on the depth and amount of particulate matter suspended in the water. For general correction at shallow depths, use a CC30R or a CC30M. To get true colors on deep dives, bring your own light source.

YELLOW CASTS

See Red Casts.

ZOOM EFFECTS

The effect of zooming a lens during exposure is to produce streaks that seem to radiate out from the center of your picture. To do this effectively, you need fairly long exposures, usually 1/2 sec. or longer. Exposures of this duration are hard to get in daylight because most zoom lenses do not stop down to more than $f/16$ or $f/22$.

To cut down the light for long exposures without affecting color quality, use neutral density filters (see also Chapter 7). These filters are graded according to density on a logarithmic scale or by filter factor, depending on the manufacturer. On the logarithmic scale, each .3 of density increases the exposure factor about $2\times$ or 1 f-stop. For example, an ND .6 has a factor of $4\times$ or 2 f-stops; an ND .9 has a factor of $8\times$ or 3 f-stops. Beyond this point, the correspondence between f-stops and .3 density breaks down slightly, but it is adequate for a close guess. See Chapter 7 for a more exact chart.

A polarizer is also an effective neutral density filter with a factor of about 3× or 1½ ƒ-stops. For scenic work where flesh tones are not important, you can get longer exposure times by combining a polarizer with a dark-colored filter, such as the Medium Red (No. 25), for a total factor of 24× or 4½ ƒ-stops.

7

Advanced Filtration

This chapter is written for the experienced filter user and for those who are curious about the variables in filter usage. It deals with such questions as: What is a filter factor and how exact is it? Or, short of using a Tri-Color temperature meter, is there any way to determine exactly what filters to use for color correction? If questions like these interest you, read on; if not, the other chapters provide most of the data you need to use filters effectively.

THE TRUTH ABOUT FILTER FACTORS

The basic filter factor provided by the filter manufacturer is an estimate of the amount of additional exposure you will need to get identical exposures of a totally neutral subject in filtered and unfiltered shots. The key here is neutral subject. In practice, the filter is used to alter color, or, in black-and-white work, to alter the apparent luminosity of colored subjects. Yet the filter factor is based on a gray subject, such as an 18 percent gray card.

To see how this works, take the example of a Medium Red (No. 25) filter used with a common black-and-white film such as Plus-X. Put a gray card on an easel, or tack it up to something; then with your camera lens focused on

FILTER FACTORS FOR COPYING WITH BLACK-AND-WHITE PANCHROMATIC FILMS IN TUNGSTEN LIGHT

Filter Color and Wratten No.	Exposure Increase in *f*-Stops
Medium Yellow (8)	$2/3$
Yellow-Green (11)	$1\,2/3$
Yellow-Green (13)	2
Dark Yellow (15)	1
Light Red (23A)	$1\,2/3$
Medium Red (25)	$2\,1/2$
Dark Blue (47)	3
Dark Blue (47B)	4
Light Green (56)	$2\,2/3$
Dark Green (58)	3

infinity, move the camera toward the card until it fills the entire frame. Next find the correct exposure for an unfiltered shot and expose one frame of film. Then compute the correct exposure for the Medium Red filter—that is, open up 3 *f*-stops—and expose a second frame, this time through the filter. When you develop the film, the density of the filtered and unfiltered exposures should be almost identical, and if your initial exposure was correct and your processing and contact-printing technique is down pat, then a contact print should result in two 18 percent gray frames that exactly match the original subject. That's the theory anyway.

You probably will not get perfect matches between the filtered and unfiltered shots or between a contact print and the original gray card because of the many uncontrolled variables. For example, the gray card may not be perfectly neutral; the light on the card varies depending on when and where you make the test; and the spectral sensitivity of the film will vary from brand to brand and batch to batch. All these variables add up, which is why responsible filter and film manufacturers are always quick to point out that the filter factors are simply guides to exposure.

The next step in understanding exposure through

filters is to take a red subject and a green subject of about the same brightness as the gray card and place them side by side on the card. Unfiltered, the red, green, and gray will show very little difference in luminosity when photographed on Plus-X. If you use the Medium Red filter with a standard 8× filter factor, the green subject will become much darker than the card, the red subject will be substantially lighter, and the gray card will scarcely be affected at all. In other words, the contrast between the colored subjects has been markedly increased.

The only completely predictable factor in this last example is the effect on the gray card when correct filter compensation is used. Without prior testing, there is no practical way of knowing just how much separation you will get between red and green. Much depends on the spectral composition of the subject itself. For example, green leaves reflect large amounts of deep-red, and a red apple reflects some green, so trying to separate a red apple from green leaves using a Medium Red filter will lead to barely perceptible results. (Yes, there are "examples" of strong separation using just this subject/filter combination. Quite possibly additional techniques were required to get those photos, such as developing for high contrast, masking, printing on high-contrast paper. So don't be discouraged if you can't duplicate them.)

Most artificial colors respond well to separation through the use of filters.

If your subject is entirely red—a neolithic clay pot, for example—then you might select a red filter to help bring out detail. By photographing through a filter the same color as the subject, you can get increased separation of detail. For best results, use a lower filter factor than the one intended to give equivalent exposures of neutral subjects. Your object is to render a red subject normally through a red filter. The full filter factor will overexpose it. About half the usual exposure compensation will do as a starting point. A Light Red (No. 23A) filter would be suitable for the red clay pot.

Filter factors are a good guide to general exposures, but do not feel locked in by them. The right exposure is always the one that gives you the most effective results.

141

Without filtration, this photo of an artificial red flower with green leaves on a neutral gray background provides very poor tone separation. All values fall in the mid-range of the scale.

With a Medium Red (No. 25) filter and a half-stop exposure increase, the flowers have approximately the same value as in the unfiltered shot, but the leaves and background are nearly black.

A two-stop exposure increase with the Medium Red (No. 25) filter provides all the correction this tungsten- lighted setup seems to require. The neutral gray background is tonally similar to that in the unfiltered scene; the flowers are substantially lighter, although they contain plenty of detail; the green leaves are dark but still carry detail.

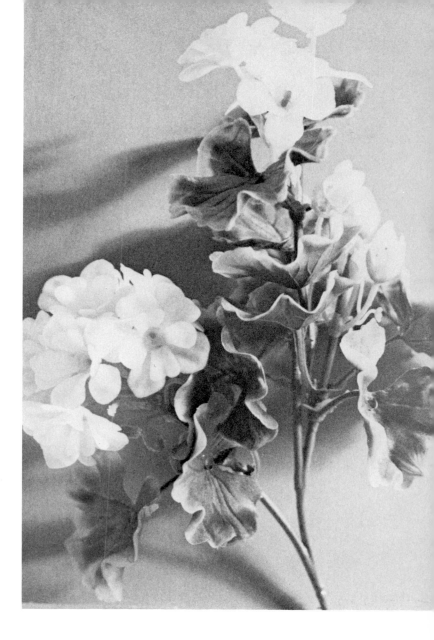

A four-stop exposure increase with the Medium Red (No. 25) filter results in a loss of detail in the reds. This exposure is correct for the green leaves only.

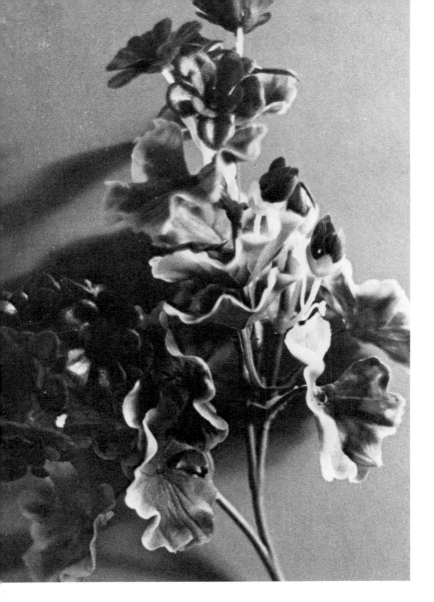

A Dark Green (No. 58) filter turns the red flowers almost black but has little effect on the neutral background when a correct three-stop exposure increase is used. The effect on the green leaves is less than might be expected, probably because the artificial leaves contain significant amounts of yellow dye. The red portion of the yellow dye would be absorbed by the green filter.

146

PERFECT COLOR—ALAS

There is absolutely no way that you will ever get a perfect color match between an original subject and a transparency or print. The visible spectrum contains a continuously variable range of wavelengths running from about 400nm (violet) to 700nm (deep-red). Color film contains dyes that

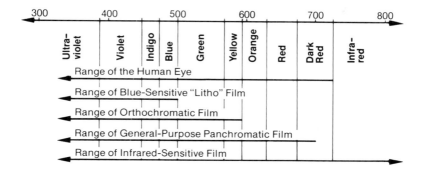

Range of the spectrum (in millimicrons) compared to the sensitivity of the human eye and the sensitivity of various films.

involve only a small portion of the visible spectrum. These dyes are cyan (blue-green), magenta (blue-red), and yellow (red-green). When seen in various combinations, these dyes produce the illusion of a full visible spectrum, but it is only an illusion, as a quick comparison between a color slide or print and the original subject will quickly make apparent.

The narrow bands of colors reproduced by the dyes in color materials leave out a substantial portion of the spectrum. Although we perceive the dye combinations as producing a full range of colors, they do not, and the colors that are left out are colors that we can see when they are present. Thus there is a visual richness to nature that is never fully captured on film and cannot be recaptured through filtration.

The purpose in corrective filtration with color films is to make the resulting color more pleasing, not more perfect, since film is an imperfect medium anyway.

147

FILTER FACTORS FOR USE WITH ORTHOCHROMATIC* FILMS IN TUNGSTEN LIGHT

Filter Color and Wratten No.	Exposure Increase in *f*-Stops
Medium Yellow (8)	1
Yellow-Green (11 or 13)	Do not use
Dark Yellow (12)	1⅓
Dark Yellow (15)	1⅔
Red (23A, 25, or 29)	Do not use
Dark Blue (47B)	3
Dark Green (58)	2⅓

*Orthochromatic films are sensitive to blue and green light but not to red. They are used mainly for copying and by the printing trades. They have not been used in general photography for more than 50 years.

COLOR TEMPERATURE AND THE DECAMIRED SYSTEM

When the color temperature scale was originally devised, the light source was a black-body radiator that glowed differently when heated to different temperatures. That's how the word "temperature" got into the scale. Today, tungsten lights, including household light bulbs, studiofloods, and quartz lighting, closely match the characteristics of the original color temperature scale light source. Thus the scale refers accurately to tungsten light sources. It does not function as a descriptor of daylight or fluorescent light because their spectral characteristics are substantially different from that of tungsten light.

More importantly, the color temperature scale is not proportional, which means that a change of 100 K at one point on the scale is very different from a change of 100 K at some other point on the scale.

To get around this, a modification of the color temperature scale was devised. This is called the DecaMired (DM) system, in which the warming or cooling effect of a light-balancing or conversion filter is accurately indicated by a single number. Of course, the DM value of a light source does not indicate the proportion of green in a light, so

148

DECAMIRED FILTER SELECTION CHART*

Film Type	Light Source	Filter	Exposure Increase in f-Stops
Daylight	Open shade (bluish daylight); slight overcast; blue flashbulbs	R1½	¼
	Electronic flash	R3	⅓
	Average sunlight plus skylight	None	—
	Late P.M. or early A.M. sunlight	B1½	¼
	Clear flashbulbs	B6 + B1½	1¼
	3400 K photofloods	B3 + B6 + B1½	2
	3200 K studiofloods	B12	2
	100-watt light bulb	B12 +B3	2½
Type A (balanced for 3400 K lamps)	Open shade (bluish daylight); slight overcast	R12 + R3	1⅓
	Electronic flash and blue flashbulbs	R12	1
	Average sunlight plus skylight	R3 + R6 + R1½	1
	Late P.M. or early A.M. sunlight	R3 + R6	¾
	Clear flashbulbs	R3	⅓
	3400 K photofloods	None	—
	3200 K studiofloods	B1½	¼
	100-watt light bulb	B6	1
Tungsten (Type B— balanced for 3200 K)	Open shade (bluish daylight); slight overcast	R12 + R3 + R1½	1½
	Electronic flash and blue flashbulb	R12 + R3	1⅓
	Average sunlight plus skylight	R12	1
	Late P.M. or early A.M. sunlight	R1½ + R3 + R6	1
	Clear flashbulbs	R3 + R1½	½
	3400 K photofloods	R1½	¼
	3200 K photofloods	None	—
	100-watt light bulb	B3	½

*Filter suggestions given here should be considered as starting points for correction only. More or less filtration may be required to suit personal tastes.

its values may be slightly out of line with daylight, but the values provided in the accompanying charts are close enough for figuring. (Tri-Color temperature meters remain the only means of getting accurate filter recommendations for specific light sources.)

The DM scale is simply a scale in which color temperature values are proportional. For example, a filter that produces a 3 DM shift in color temperature will give you the same degree of change on the scale for warm

149

EXPOSURE INCREASE FOR DECAMIRED FILTERS

R Series	Exposure Increase in f-Stops
R1½	¼
R3	⅓
R6	½
R3 + R6	¾
R12	1
R12 + R3	1⅓
R12 + R6	1½

B Series	Exposure Increase in f-Stops
B1½	¼
B3	½
B6	1
B3 + B6	1½
B12	2
B12 + B3	2½
B12 + B6	3

tungsten light as for cold skylight. A subject illuminated by an overcast sky has a value of roughly 15 DM. Standard daylight is about 17 DM. To balance the light on a subject illuminated by an overcast sky with standard daylight, you would need a filter that produced a shift of about +2 DM. A similar +2 DM shift is required to correct photoflood light (29 DM) to studioflood (31 DM) quality. A +2 DM shift is roughly equivalent to that provided by an 81A light-balancing filter, or a DM R1½ filter.

In the accompanying charts, you will find the DM values for common light sources as well as the approximate DM equivalent for light-balancing filters.

DM filters are available individually or in sets that usually consist of two series. The R (red) series, equivalent to the 81 series of light-balancing filters, usually runs R1½ (+1.5 DM), R3 (+3 DM), R6 (+6 DM), and R12 (+12 DM), which is equivalent to an 85B conversion filter. The B (blue) series, equivalent to the 82 series of light-balancing filters, runs B1½ (−1.5 DM), B3 (−3 DM), B6 (−6 DM), and B12 (−12 DM), which is equivalent to an 80A conversion filter.

As you work out light/filter combinations, you will find that not all values fall exactly on a filter number or combination of filters in your set. The general rule is to use the next lower DM value or combination of values.

When you use DM filters in combination, add the DM values to find the total DM value of the combination. Do the

DECAMIRED VALUE OF COMMON LIGHT SOURCES

Light Source	Value
Clear blue northern skylight	6–4
Open shade (subject illuminated by blue skylight)	9
Hazy skylight; overcast sky	12
Electronic flash (uncorrected)	16–15
Blue flashbulb	17
Hazy sunlight	17
Average daylight	18–17
A.M. or P.M. sunlight	19
500-watt blue photoflood	19–21
500-watt photoflood	29
500-watt studioflood	31
100-watt light bulb	35
75-watt light bulb	35
40-watt light bulb	38

DECAMIRED SHIFT VALUES OF LIGHT BALANCING AND CONVERSION FILTERS

Filter Color	Filter No.	DecaMired Shift Value	Exposure Increase in f-Stops
	82	−1	$\frac{1}{3}$
	82A	−2.1	$\frac{1}{3}$
	82B	−3.2	$\frac{2}{3}$
Blue	82C	−4.5	$\frac{2}{3}$
	80D	−5.6	$\frac{2}{3}$
	80C	−8.1	1
	80B	−11.2	$1\frac{2}{3}$
	80A	−13.1	2
	81	.9	$\frac{1}{3}$
	81A	1.8	$\frac{1}{3}$
	81B	2.7	$\frac{1}{3}$
	81C	3.5	$\frac{1}{3}$
Reddish	81D	4.2	$\frac{2}{3}$
	81EF	5.2	$\frac{2}{3}$
	85C	8.1	$\frac{2}{3}$
	85	11.2	$\frac{2}{3}$
	85B	13.1	$\frac{2}{3}$

same with the DM values of light-balancing filters. Combine only filters of the same color. If you mix red and blue DM filters, you will get unpredictable results.

To find the filter factor for DM or light-balancing filters used in combination, add the exposure increase in f-stops.

You will find that the accompanying chart can be useful for determining the starting point for corrective filtration with various types of light. If you have light-balancing filters in your gadget bag, keep them labeled with their DM values and make a copy of the accompanying chart to keep with the filters.

To find the DM value to use for correction, subtract the DM value of the light source from the DM value of the film. The DM value for Kodak film is 18; the DM value for some European films is 17. The DM value for tungsten film is 31. The DM value for Type A and most Super 8 films is 29.

If the result is a positive number when you subtract, use an R or 81 series filter. If the result is negative, use a B or 82 series filter.

NEUTRAL DENSITY FILTERS

The neutral density, or ND, filter is used to control exposure without affecting color or contrast. ND filters are available in various densities that allow the user to increase exposure from 1 to 16 or more f-stops, depending on the filter or combination of filters used.

ND filters are seldom used in general photography because the combination of lens diaphragm and variable shutter speed ordinarily provide sufficient flexibility. ND filters are occasionally used in motion-picture photography when the camera director feels that a single aperture should be used for all shots. In this case, ND filters would be used in place of the aperture for exposure control.

ND filters may be numbered according to their exposure factor or in logarithmic increments in which .3 is roughly equivalent to 1 f-stop reduction in transmittance for all wavelengths of light.

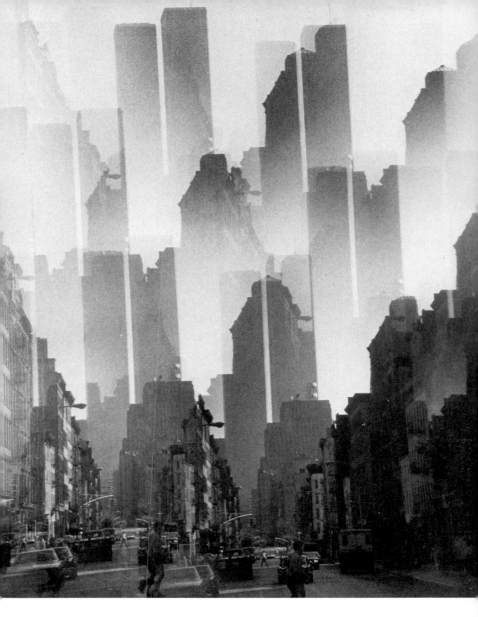

"Homage to 1924." The variety of effects that can be achieved using filters is mind boggling. Here a five-parallel-facet multiple-image prism was combined with a six-facet prism and a Medium Red (No. 25) filter to produce this unique interpretation of the World Trade Center. Photo © Robert A. Smith, 1978.

One of the most frequent uses of a neutral density filter is to prevent overexposure when fast films are used with cameras that do not permit extensive adjustments for exposure. In this photo, overexposure with a fast film produced a washed-out image lacking in detail.

FILTERS FOR SCIENTIFIC USE

An old rule of thumb states that a filter lightens its own color and darkens its complementary color. It is not a very useful rule in practice, which is why it was not mentioned earlier. First, it requires that the user be absolutely certain of what a complementary color is; second, it assumes that a filter really does block its complementary colors, which is only partly true.

154

Use of a Tiffen ND 0.6 filter produced correct exposure without camera adjustments.

For example, a Yellow-Green correction filter passes not only green but red and a considerable amount of blue light as well, despite the fact that visually it looks much like the Dark Green (No. 58), which passes practically nothing but light in the green region of the spectrum.

The exact transmission character of any filter depends on the nature of the dyes used in the filter, the glass, density, and other material in the filter. The exact effect a filter will have is revealed by a graph that plots percent transmittance against wavelength. The resulting line is

known as a *filter curve*. It shows exactly how much of each wavelength is absorbed by the filter and how much is transmitted.

Although practically useless in general photography, filter curves are occasionally valuable to research scientists, design engineers, and technicians. Interested persons can get spectral transmission graphs from the manufacturers of quality filters.

Appendix

Metric Conversion Information

When You Know	Multiply by	To Find
inches (in.)	25.4	millimetres (mm)
feet (ft.)	0.3048	metres (m)
miles (mi.)	1.609	kilometres (km)
ounces (oz.)	28.349	grams (g)
pounds (lbs.)	0.453	kilograms (kg)
pounds per square inch (psi.)	0.0703	kilograms per square centimetre (kg/sqcm)
cubic feet (cu. ft.)	0.0283	cubic meters
Fahrenheit temperature (F)	1.8 after subtracting 32	Celsius temperature (C)

ASA AND DIN FILM SPEEDS

ASA	DIN	ASA	DIN	ASA	DIN	ASA	DIN
6	9	25	15	100	21	400	27
8	10	32	16	125	22	500	28
10	11	40	17	160	23	640	29
12	12	50	18	200	24	800	30
16	13	64	19	250	25	1000	31
20	14	80	20	320	26	1250	32

Index

159

Minor corrections, 36–40
Misty effect, 11
Morning/evening filter, 37
Multiple exposure, 82–83
Multiple-image prisms, 15, 97–101, 127
Multiple images, 79
Multiple planes of sharp focus, 79

Neutral density (ND) filters, 15, 129, 137
Neutral gray subject, 28
Nomenclature, 18–24
Nudes, 133
Nylon stockings, as diffusers, 77

Orange filters
 Orange (No. 16), 114, 117, 119, 124, 131, 134, 136
 Dark orange (No. 21), 59
Orthochromatic films, 148

Panatomic-X, 77
Panchromatic copy film, 129
Photoflood bulbs, 32, 37, 38, 133
Photoflood light, 32, 38
Photons, 63
Plastic filters, 18
Plus-X film, 77, 129, 139, 141
Polarization and diffusion, 63–78
Polarized region of sky, 67
Polarizer(s), 15, 28, 63–69, 122, 124, 126, 127, 132, 136, 138
Processing, 29
Portraits, 63, 133

R1½ filter, 124
R6 filter, 131
Rainbow bursts, of color, 79, 96
Reciprocity failure, 42
Red casts, 133
Red filters
 Dark Red (No. 29) or F, 59, 114, 115, 126, 134
 Light Red (No. 23A), 59, 131, 141
 Medium Red (No. 25), 53–55, 83, 114, 115, 117, 119, 126, 127, 131, 134, 138, 139, 140, 141
Reflections, on surface of water, 67
Retaining ring, 21

Sandwich, 18
Scientific investigation, 114
Scientific use, 154
Seascapes, sunlit, 63
Series filter 82, 122

Series size concept, 22
Silhouettes, 80, 101
Sky-control, 85
Sky darkening, 134–136
Sky filter. See Skylight filter
Skylight filter, 33–34, 119, 122, 124, 125, 129, 136
Snow scenes, photographing, 136
Soft focus attachments, 77–78
Special-effect filters, 15
Special image variations, 79–118
Special-purpose filters, 15
Spectral-burst filter, 96
Split-field attachment, 127
Split-field lens, 110–113
Star filters, 15, 79, 86–95
Studioflood bulbs, 37, 38
Super 8 film, 32, 36

Telephoto photography, 136
Through-the-lens metering and filters, 36
Tone correction, 45
Tone separation, 45
Tri-color filters, 126
Tri-Color temperature meter, 42, 44, 131, 139

Ultraviolet filter. See UV filter
Uncoated lens, 33
Underexposure, effect on diffusion, 77
Underwater photography, 137
UV filters, 33–34, 119, 129, 136, 137

Variable-color filters, 62, 81
Vaseline, 76

Watercolor pigment, 76
White light, 12

X filter, 86

Yellow casts. See Red casts
Yellow-green filters. See Green filters
Yellow filters
 Dark Yellow (No. 12), 57–58, 117, 119
 Dark Yellow (No. 15), 51–52, 117, 119, 124, 126, 127, 131, 134
 Light Yellow (No. 6), 56, 136
 Medium Yellow (No. 8), or K2, 48–49, 122, 123, 131, 134, 136
 Yellow filter (No. 9), 57

Zoom effects, 137–138
Zoom lens, 21